Exhibition Itinerary*

The Brooklyn Museum of Art
Brooklyn, New York
July 28–October 3, 2001

The Contemporary Arts Center
Cincinnati, Ohio
January 24–March 31, 2002

Tampa Museum of Art
Tampa, Florida
April 21–June 23, 2002

Chicago Cultural Center
Chicago, Illinois
July 13–September 8, 2002

Akron Art Museum
Akron, Ohio
September 21, 2002–January 5, 2003

Norton Museum of Art
West Palm Beach, Florida
Spring 2003

The Huntsville Museum of Art
Huntsville, Alabama
October 13, 2003–January 4, 2004

*at the time of publication

my reaLITY_

contemporary art and the culture of japanese animation

Essays by Jeff Fleming, Susan Lubowsky Talbott & Takashi Murakami

Des Moines Art Center &

Independent Curators International, New York

my rea

ITY

Matthew Benedict

Lee Bul

Taro Chiezo

James Esber

Inka Essenhigh

Mika Kato

Micha Klein

Miltos Manetas

Paul McCarthy

Mariko Mori

Mr. (Masakatu Iwamoto)

Takashi Murakami

Yoshitomo Nara

Richard Patterson

Tom Sachs

Momoyo Torimitsu

Charlie White

Kenji Yanobe

My Reality: Contemporary Art and the Culture of Japanese Animation originated at the Des Moines Art Center, curated by Jeff Fleming, senior curator, and Susan Lubowsky Talbott, director. The traveling exhibition is organized and circulated by Independent Curators International (ICI), New York. The exhibition at the Des Moines Art Center was made possible by support from the Jacqueline and Myron Blank Exhibition Fund of the Des Moines Art Center, The Bright Foundation, the Lila Wallace Reader's Digest Fund, and the Greater Des Moines Community Foundation.

ISBN: 1-879003-33-3

Library of Congress Catalog Card Number: 2001131250

© 2001

Des Moines Art Center

4700 Grand Avenue

Des Moines, Iowa 50312

Independent Curators International

799 Broadway, Suite 205

New York, New York 10003

DESIGN Connie Wilson

EDITORS David Frankel, Faith Brabenec Hart, and Sheila Schwartz

PRINTING Artcraft Printing

TABLE OF CONTENTS

SUSAN LUBOWSKY TALBOTT
Director, Des Moines Art Center
&
JUDITH RICHARDS
Executive Director, Independent Curators International, ICI

FOREWORD | ACKNOWLEDGMENTS

Whenever a new cultural phenomenon arises, artists take notice. *Anime*, short for Japanese animation, influenced a generation of artists who grew up during the 1960s and '70s in post-Hiroshima Japan. As the country rebuilt itself in a frenzy of business and technology, many Japanese sought refuge from this work oriented culture in the fantasy of *anime* cartoons and *manga* comics. This imagined world portrayed a future far different from day to day reality—a future of cyborgs and superheroes with mythic destinies in sharp contrast to their own lives.

As *anime's* popularity spread beyond Asia with Pokemon games and Hello Kitty toys, its influence was also felt in European and American art circles. During the last decade, Japanese artists such as Yoshitomo Nara, Mariko Mori, and Takashi Murakami established their presence on the international art scene. The Des Moines Art Center and Independent Curators International are pleased to present *My Reality,* the first comprehensive exhibition to investigate the effect of the culture of *anime* on contemporary art.

The Des Moines Art Center and ICI are both committed to enhancing public understanding of contemporary art. To that end, *My Reality* targets an audience of adolescents, families, and young adults who may be familiar with the commercial aspects of *anime*, but not with its offshoots in today's art. Our collaboration in presenting *My Reality* follows on the heels of a similar endeavor. Last year, we launched the international tour of *Almost Warm & Fuzzy: Childhood and Contemporary Art,* an exhibition with a similarly targeted audience from youngsters to young adults. Both exhibitions feature work ranging from "cute" to provocative presented in a context that is appealing to the art-educated audience as well as the casual viewer.

Jeff Fleming, senior curator, and Susan Lubowsky Talbott, director, originally organized *My Reality* for the Des Moines Art Center. We would like to thank the artists and the lenders to the exhibition and its tour. Their participation has been critical, and we are grateful for their generosity. We are also grateful to Murakami, who contributed a thoughtful catalog essay.

The exhibition and related programs at the Des Moines Art Center were made possible by the Jacqueline and Myron Blank Exhibition Fund of the Des Moines Art Center, the Lila Wallace Reader's Digest Fund, The Bright Foundation, and the Greater Des Moines Community Foundation.

We are grateful to the staffs of both the Des Moines Art Center and ICI who worked on all aspects of this project. We give particular thanks to co-curator Fleming. Laura Burkhalter, Art Center curatorial assistant, provided valuable insights into the world of *anime,* acted as research assistant on the exhibition, and coordinated the artist biographies for the catalog. At ICI, special thanks go to Carin Kuoni, director of exhibitions; Jack Coyle, registrar; and Sarah Andress and Jane Simon, exhibition assistants, for their work on the exhibition tour and catalog.

Susan Lubowsky Talbott would like to acknowledge Marion "Kippy " Stroud for providing the "thinking time" at her Maine retreat that led to the conception of this exhibition.

On behalf of our Boards of Trustees, our warmest appreciation and thanks go to all who have contributed to the presentation of this exhibition and its tour.

LEFT
Mr. (Masakatu Iwamoto)
Adapted from
Raspberry Tea 1997

9

MY REALITY

YOUr reaLITY

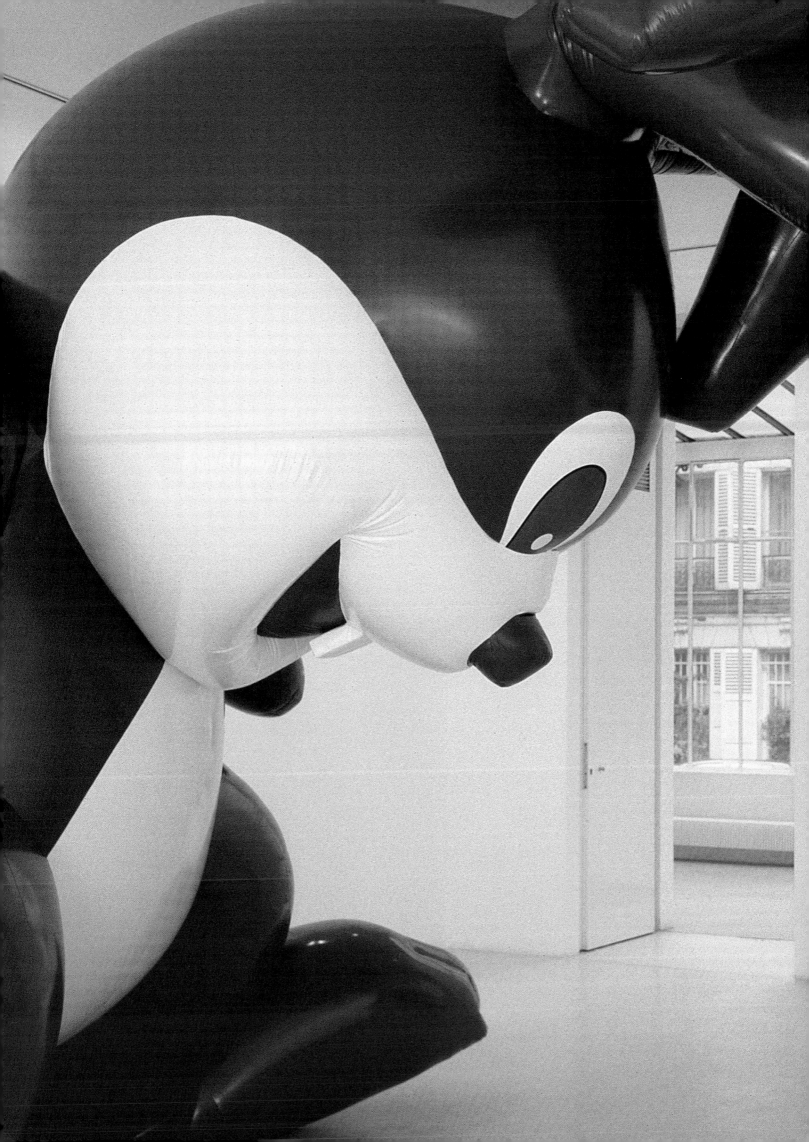

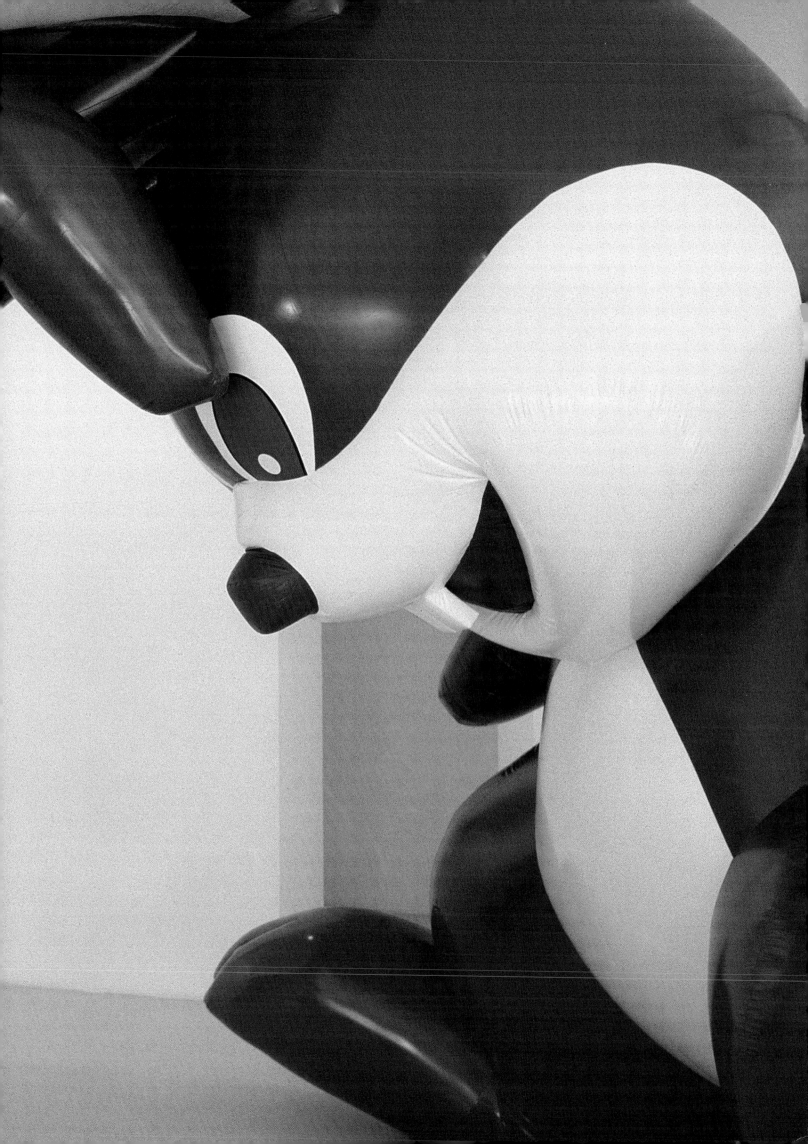

my reality, your reality

JEFF FLEMING

Playing with People's Models of the World[1]
During a recent studio visit with Momoyo Torimitsu, the artist showed me photographs of a semitropical community of Art Deco apartment buildings, lush green lawns, and stately palm trees. I mistakenly assumed that these were images of Miami's South Beach or another Florida community, but as I viewed the photographs and silently wondered what relevance they had to our discussion, Torimitsu explained that they were images of Urayasu, an affluent Tokyo suburb. After a day of shopping, office work, or school, the inhabitants of these dwellings return home—to another world. In Urayasu the Japanese mimic their vision of another time and place, fabricating a synthetic reprieve from daily routines. It is a fantasy world.

My Reality: Contemporary Art and the Culture of Japanese Animation explores the notion of the invented communal or personal reality that functions as an avenue of escape from contemporary social circumstances. For both the Eastern and the Western artists participating in the exhibition, escape derives from fantasy and play, whether through an atomic car designed to survive a nuclear holocaust or a more encompassing retreat into history, tradition, or popular culture. What reality do you use to survive? What fantasy do you create to meet your needs? My reality, your reality—it's all just an illusion.

We Want to See the Future[2]
The contemporary Japanese popular culture manifested in comic books (*manga*), animation (*anime*), music, geek culture (*otaku*), the club scene, advertising, and fashion presents a unique approach to modern life. It is a survival strategy, finding authoritative voice in social critique and reflection; yet many of its sources lie in forms of Western entertainment, such as the animated films produced by Disney, Warner Brothers, and Max and Dave Fleischer, and it embodies a sense of playfulness. In fact play and fantasy echo throughout Japanese youth culture, which has embraced them as a manifesto and exported them to the world.

Japanese popular culture reflects contemporary Japanese society, which is so heavily influenced by the West that it can be called a merging of Western and Japanese cultural entities. Japan's initiation in Western culture began in the mid-to-late-nineteenth century and accelerated after World War II, when modern Japan took form. In the war-devastated nation, America became the model, and capitalism and commodity-driven enterprises flourished. The merger was uneasy, however, creating conflict in the Japanese mind, and this in turn led to the creative explosion that now defines Japanese popular culture.[3]

This uneasiness is caused by the collision of the premodern and the postmodern.[4] Contemporary postmodern conditions, such as the reduced social emphasis on the individual and the negation of uniqueness, are familiar and longstanding in Japanese society, as is the idea of a communal or group dynamic. Western aesthetic concepts—including the intrinsic value of the art object and the elevated status of its creator—now merge with these traditional Japanese cultural concerns. This coalescence, and the fusion of popular culture with forms of entertainment, celebrate what has become a uniquely Japanese expression.[5]

LEFT
Urayasu City, Japan

PREVIOUS PAGE
Momoyo Torimitsu
Somehow I Don't Feel Comfortable 2000

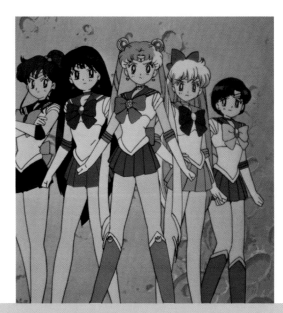

We Wanted to Create a World, and
We Wanted to Look at It from Space[6]

Anime is a dominant force in Japanese popular culture. Derived from *manga*, it is enjoyed by broad audiences and targeted to all age groups. *Anime* has attained almost cult status among young people around the world through commercial entities, animated series, and organized followers. It is technology-friendly, presenting technology as a positive social force. Much *anime* consequently has a futuristic or science fiction flavor. The pervasive presence of *anime* in Japan and other Asian countries has led to its adoption by many Japanese and Asian artists. Western artists in turn have been influenced by their Asian counterparts, as well as by the underground popularity of *anime* in America and Europe.

 Anime is an extension of *manga*, which grew to enormous popularity in Japan after World War II and continues to be a cheap and accessible form of entertainment. Many *manga* are serial in format and are printed on newsprint in black and white. Most important, *manga* is open to individuals to participate on an amateur level. Anyone can produce a comic book, and literally thousands do. *Manga*, moreover, is not aimed solely at young people. Along with the subgenres for boys and girls, there is also adult *manga*—violent, erotic, and sexually graphic.

 Osamu Tezuka was one of the first artists to move from *manga* to animated film, and is considered the Walt Disney of Japan. American audiences know Tezuka through *Astro Boy*, the first Japanese animation shown on American television, in 1964. (Another early *anime* known to American audiences is *Speed Racer*, produced by Tatsunoko

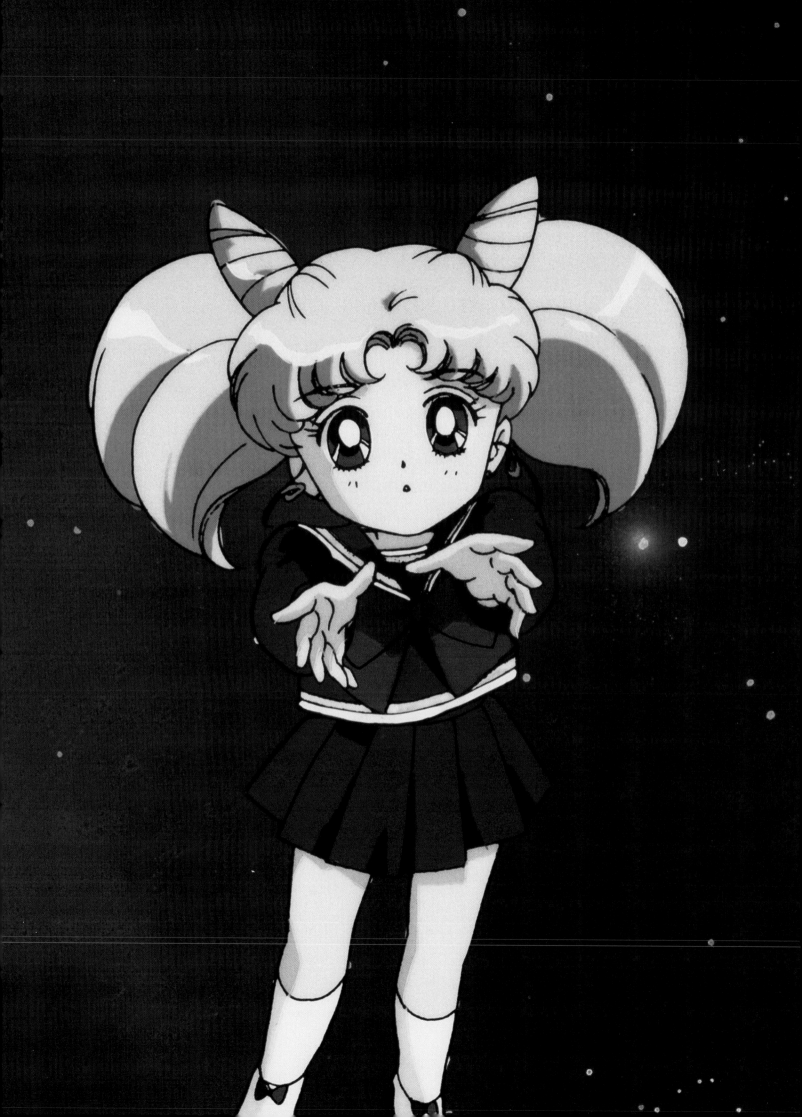

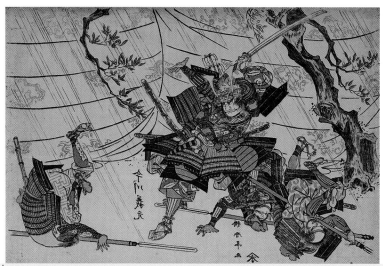

ABOVE
Katsukawa Shuntai
The Samurai Imagawa Yoshimoto, n.d. (not in exhibition)
Woodcut on paper
10 3/8 x 15 7/16 inches
John C. Huseby Print Collection of the Des Moines
Art Center through Bequest, 1994.302

RIGHT Tom Sachs **Super Dynamite Soul** 1998
(Des Moines only)

Studio and first aired on American television in 1967.) Tezuka has influenced a generation of Japanese *manga* and *anime* artists. Filmmakers Hayao Miyazaki and Isao Takahata took up his mantle at Studio Ghibli, which now creates Japan's most popular *anime*. Their most successful film, and in fact the most successful Japanese film ever in the Japanese market, is Miyazaki's *Princess Mononoke* (1997). (Its Japanese box office take is only surpassed by James Cameron's film *Titanic*, of 1998.[7]). Ironically, Disney has purchased the English-language rights to eight of Studio Ghibli's films, including *My Neighbor Totoro* (1988) and *Kiki's Delivery Service* (1989). These films have been dubbed in English using the voices of English-speaking actors such as Kirsten Dunst and Phil Hartman.

Anime arrived in full force in America in the 1980s and '90s with the import of Japanese videos, the accessibility of travel, and the advent of technology, such as the Internet, that could be used to distribute its images. As with all capitalist products, the market drives the production of *anime* and *manga*, which support and create a fantasy life filled with unlimited freedoms. As such they are phenomenally appealing. *Anime* and *manga* in their purest forms reflect a social consciousness and the idea of boundless possibilities.[8]

My Reality: Contemporary Art and the Culture of Japanese Animation

The themes found in *manga* and *anime*—futuristic technology, cyborgs, fantastical creatures, postapocalyptic landscapes, gender roles, consumerism—and visual or stylistic elements such as the ubiquitous notion of cuteness, and a planar approach to painting, are reflected throughout this exhibition. *My Reality* looks at the shared concerns of Japanese and Western artists and explores parallel mind-frames and approaches to making art. The Japanese artists in the exhibition—Taro Chiezo, Mika Kato, Mariko Mori, Mr. (Masakatu Iwamoto), Takashi Murakami, Yoshitomo Nara, Momoyo Torimitsu, and Kenji Yanobe—and the Korean artist Lee Bul merge Western influences with traditional art forms, such as the wood-block printing and art of Japan's Edo period (1615–1868).[9] Almost all of these artists were born in the 1960s, when Japan was re-creating itself as an industrial world power. They were inundated with *manga* and *anime*—and with concepts of the new Japan, which was wrestling with a sense of self-identity as an increasingly strong part of the modern capitalistic world, yet was tied to a long and distinguished past.

Most of the Western artists in the exhibition were also born in the 1960s. Matthew Benedict, James Esber, Inka Essenhigh, Micha Klein, Miltos Manetas, Paul McCarthy, Richard Patterson, Tom Sachs, and Charlie White share concerns and

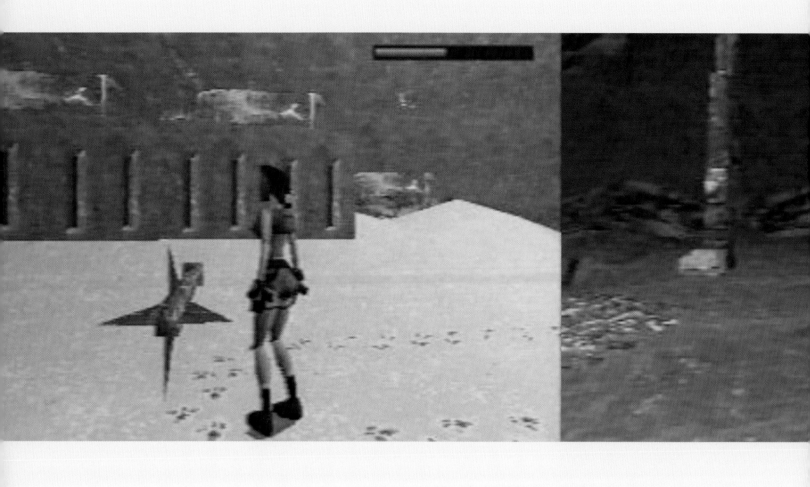

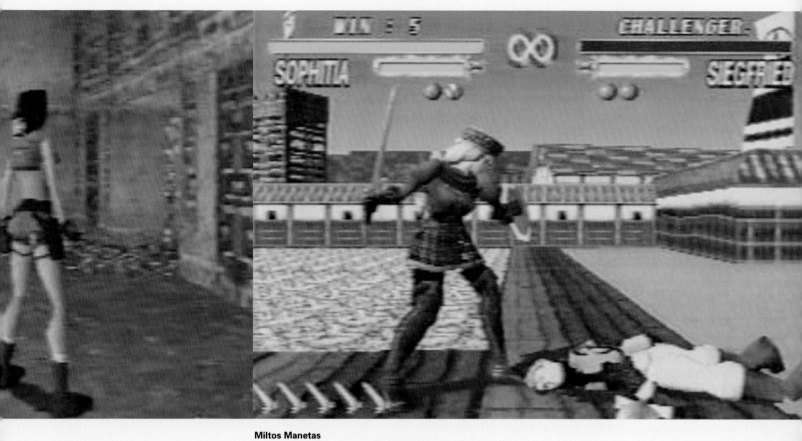

Miltos Manetas

LEFT TO RIGHT **Flames I, Flames II and I am Sorry** 1997 (video stills)

influences similar to those of their Asian counterparts. The ways in which notions of entertainment, play, escapism, and futuristic technology found in anime cross over into American and European culture are evident in the work of these artists, from McCarthy's fascination with cartoon characters of all kinds to Klein's glossy images inspired by club culture. Some of these artists seem to develop in parallel, while others find a specific source or inspiration for their art in anime.

Both the Western and the Asian artists in the exhibition appropriate recognizable anime characters. Sachs's flamboyant arrays mimic commercially available Hello Kitty merchandise, in Super Dynamite Soul (1998), or an isolated Hello Kitty–ish figure, in Lost in the Wilderness (2000–2001). Esber borrows the anime character Mon, Mon from the Japanese magazine Candy Time to create the stretched and exaggerated images in Mon, Mon #2 (1997), and Chiezo includes Sailor Moon in his painting Angry Girl (1996), which combines a Western view of modernity with contemporary Japanese culture, juxtaposing an icon of American modernism—Abstract Expressionist painting—with a computer-generated image of the anime icon. Sailor Moon, the leader of anime's first all-female group of superheroes, worries about saving the world while pondering what she will wear on Saturday night. She and the sweetness—and pinkness—of Hello Kitty reflect the Japanese concept of "high school girl culture," which presents young girls as innocent and shy while simultaneously seductive and sexually powerful. In this work our hero holds in her hand a power wand topped with a bright red sphere, reminiscent of Japan's national flag.

Sharing a similar sensibility, McCarthy uses animation for source material, looking to Disney's 1937 classic Snow White and the Seven Dwarfs, for example, in his Dwarf Heads (2000). A provocateur and critic of postmodern society through a variety of performance and technology-based media, McCarthy examines television, film, and consumer products in his investigations of psychosexual anxieties. After a visit to Tokyo where he met Murakami, McCarthy invited the young Japanese artist, as well as Nara, to teach at UCLA. The experience proved influential for the artists on

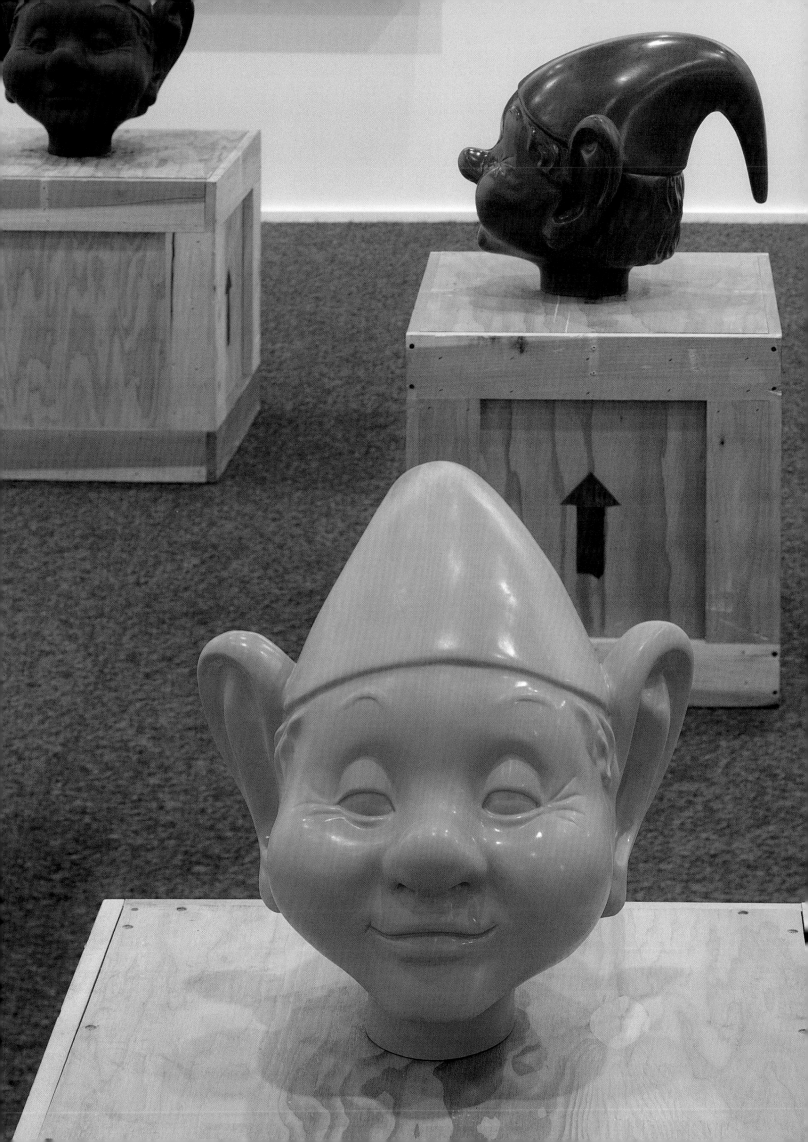

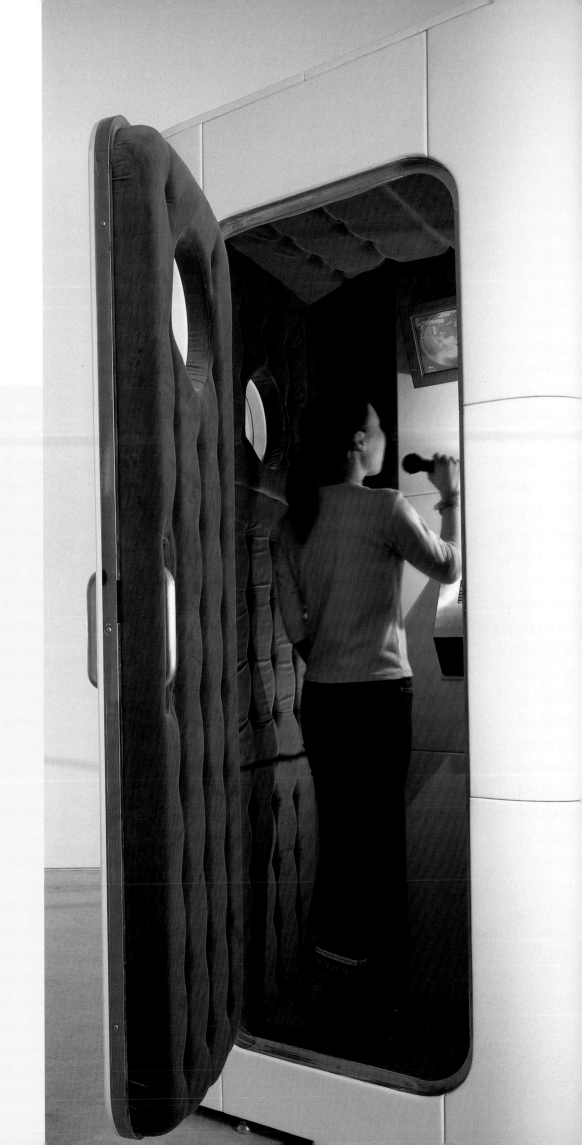

PREVIOUS PAGE
Mr. (Masukatu Iwamoto)
Venus #2 2001

Lee Bul
LEFT **Gravity Greater Than Velocity II** 1999
ABOVE **Gravity Greater Than Velocity II (Amateurs)** 1999
(production still)
RIGHT **Gravity Greater Than Velocity II (Amateurs)** 1999
(still from digital videos on DVD)

both sides of the Pacific. Murakami and Nara also create *anime*-derived characters in works such as *DOB in the Strange Forest* (1999) and *Little Ambassador* (2000) respectively. In Mr.'s untitled wall installation, numerous faces and figures drawn on discarded paper receipts deploy the visual conventions of *manga* and *anime*, such as large round eyes, vibrant hair color, and "cuteness." The images also deal with Japanese notions of feminine beauty. Likewise, in *Sunrise* (1999), Kato uses *anime* conventions to depict a small child with enlarged eyes and a tiny mouth—symbols of innocence and wisdom.

Manetas makes direct use of Japanese animation through his appropriation of video and/or computer games. A kindred spirit to *anime* artists, he reflects the computer age by copying it, videotaping popular video games such as Eidos's *Tomb Raider* and Namco's *Soul Blade*, both made for Sony Playstation. *Flames I* and *Flames II* (both 1997) present images of the video icon Lara Croft, dodging swinging axes or poison darts as she attempts to cross a snow field or an architectural maze. *I am Sorry* and *Videoday* (both 1997) also focus on a young woman, Sophitia, who battles a young male warrior. Although knocked down and brutally beaten, she always wins, then politely remarks, "I will never forget you," or "I am sorry." (Young female heroines are popular in *anime* and *manga*.) *Tomb Raider* and *Soul Blade* are well-known to any lover of video games. Manetas's appropriation of these games within the realm of fine art follows the lead of McCarthy and American Pop art even as it parallels the efforts of Japanese artists using *anime* to mirror popular culture.

Lee Bul's karaoke booths *Gravity Greater Than*

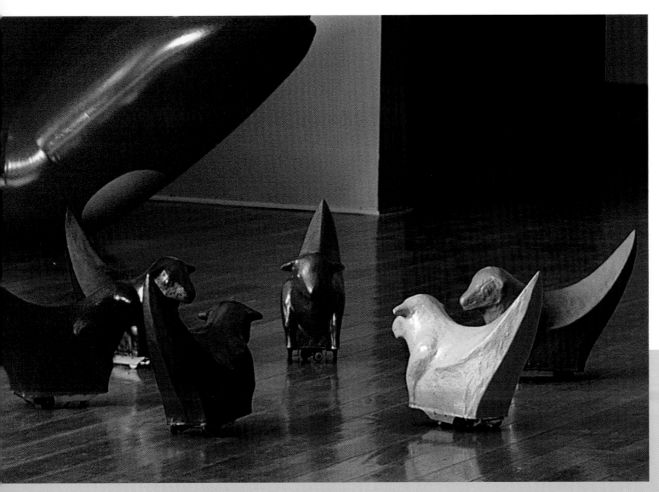

ABOVE Taro Chiezo **Lamb Bananas** 1994

RIGHT James Esber **Mon Mon 2** 1997

Velocity I and *II* (1995) embrace popular music, an important element in Japanese and Western youth culture, and have an undertone of *anime*. These space-age capsules have padded brown interiors or adopt *anime's* corrosive green or pink palette, the latter color referring to Hello Kitty. This installation presents an experience both private and public: each karaoke booth allows one person to sing along in solitude, and in a somewhat soundproof space, from a display of the words of Western pop songs such as Abba's *Dancing Queen* and Bruce Springsteen's *Born to Run*. Meanwhile a second projection of the same words on the wall outside the booth allows for group participation. On both displays, the words appear over images of Korean high school girls dancing and laughing in their school uniforms. This is yet another reference to the significance of the female figure in *anime*.

Mori borrows popular *anime* conventions in the futuristic airport setting of her photograph *Last Departure* (1996) and the computer-generated elements and spiritual nature of the video *Kumano* (1999). Mori trained in fashion, and was a fashion model early in her career. She is interested in the notion of fashion as both a culture and a commodity-driven enterprise, and uses a variety of contemporary technologies to investigate feminine cultural stereotypes. Essenhigh's futuristic canvases, exemplified by *Cosmos* (1998) and *The Adoration* (1999), present slick images of mutant figures wrestling in a biological or technological quagmire. Based in the visual appearance of Japanese animation, her painting exemplifies Murakami's description of the structural methodology of contemporary Japanese visual art—an extreme planarity of the image, or "super flat."[10]

Another recurring convention of *anime* is the mutant, the monster, or the cyborg. Chiezo's rainbow-colored *Lamb Bananas* (1994) comprises half a banana and half a lamb resting upon simple mechanisms that mobilize the objects erratically. In Chiezo's work the future is uncertain: life is part biology, part machine. Technology and also play can transform the banality of the commonplace into fantasy. Bul too works with mutant concepts in her futuristic porcelain cyborg *Untitled (Cyborg Pelvis and Leg)* (2000), and uses technology to explore

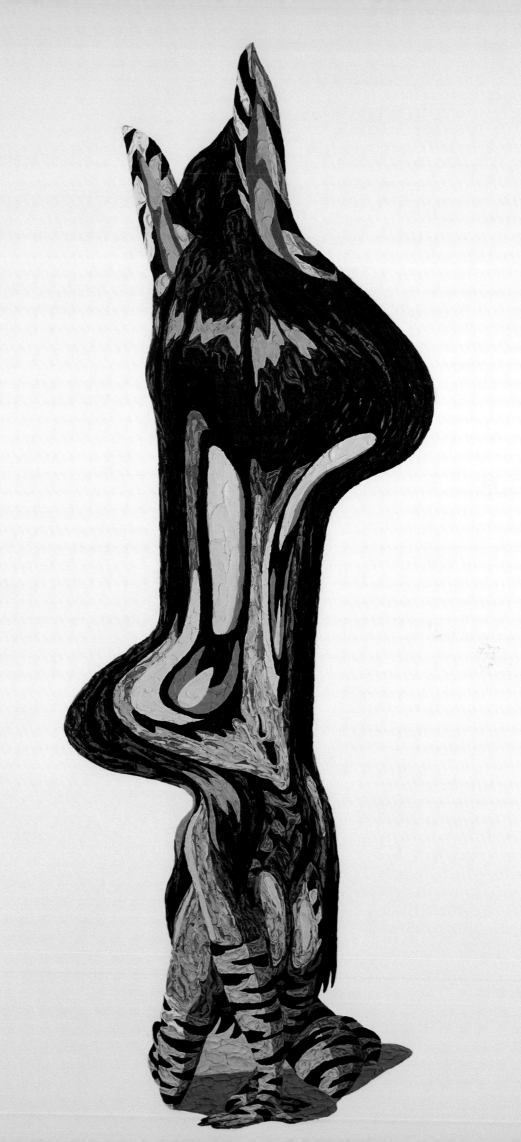

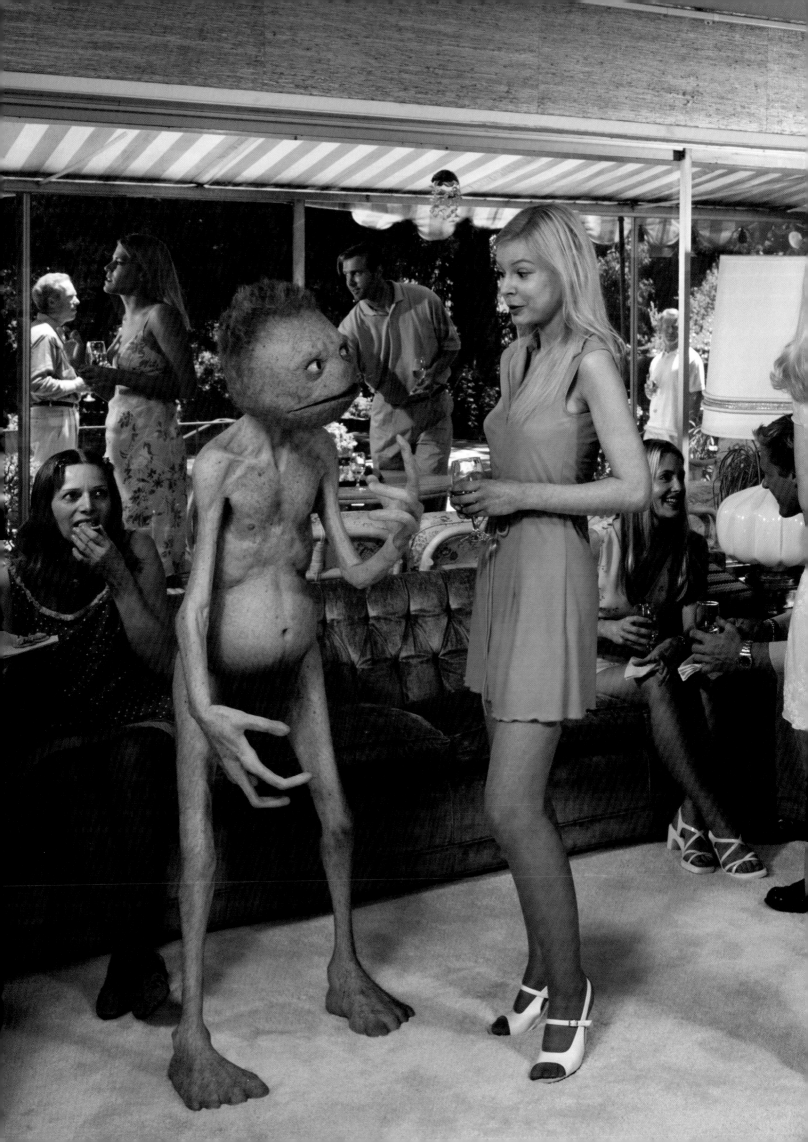

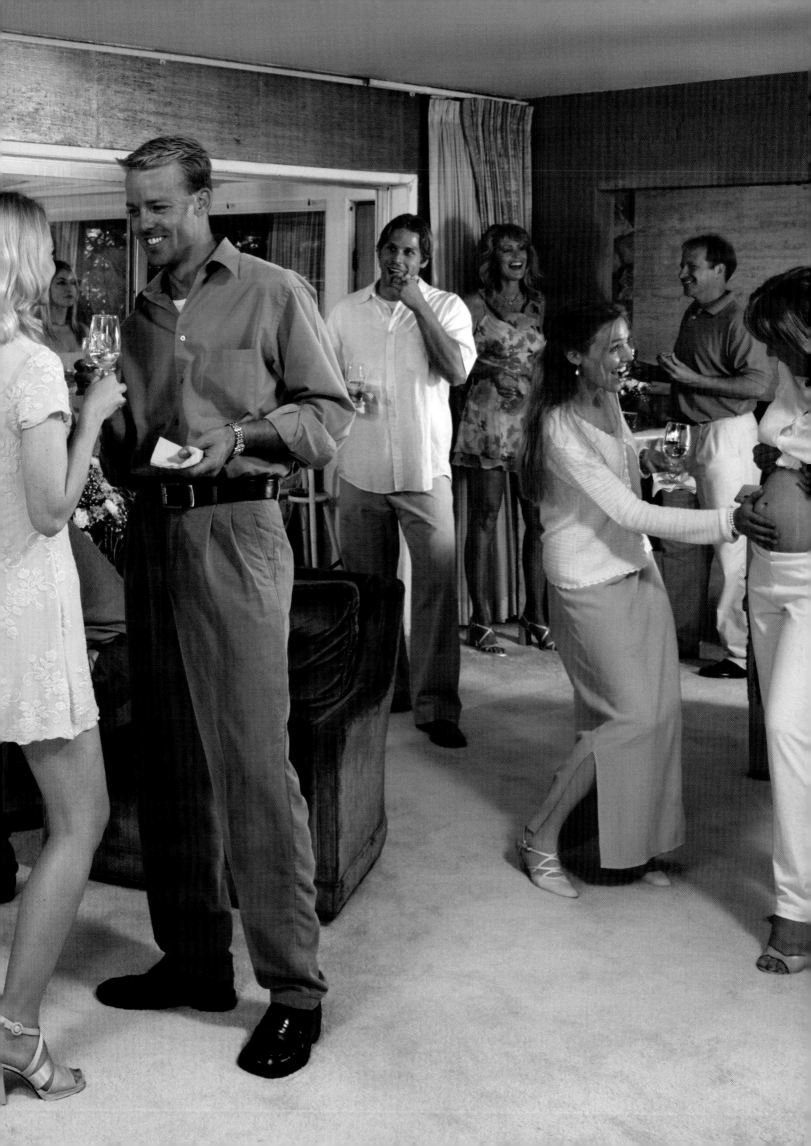

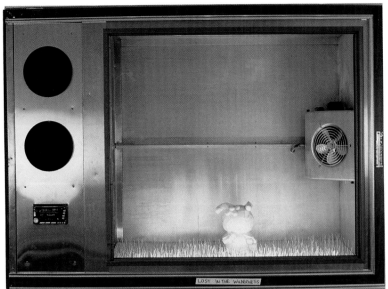

ABOVE Tom Sachs **Lost in the Wilderness** 2000–2001

RIGHT Richard Patterson **Three Times a Lady** 1999

PREVIOUS PAGE Charlie White **The Cocktail Party** 2000 (detail)

gender roles, particularly the feminine. Likewise White creates a horrific but somewhat lovable creature in the series "Understanding Joshua," and gives him life by injecting him into social situations. *The Cocktail Party* (2000) and *Ken's Basement* (2000)—large-scale light-jet photographic prints mounted on Plexiglas, glossy and seductive— depict common social situations featuring an uncommon character, Joshua, who is both cute and repulsive. In these obviously fabricated situations, part comedy and part horror movie, an unknown drama unfolds or lies just under the surface.

Other Western artists present parallel approaches. In *The Trumps* (1998–2000), Benedict uses plastic toys and found objects from popular culture to create a parade of monsters and mutants. Klein, with his glossy, futuristic image *Virtualistic Vibes, Space Nicky* (1996), looks to mutants and technology as well as music, sex, and drugs. The British-born Patterson also employs toys and the notion of play. In *Three Times a Lady* (1998) he selects a typical toy for boys (a plastic soldier resembling a World War II G.I.), covers it with globs of paint, photographs the result, and then renders it on canvas as if it were a still life. Removed three times from the original, the work is an enormous image of a toy transformed into a creature from another world and time.

All of the artists explore notions of entertainment and play, even within the serious concept of survival. Yanobe's playful atomic cars are a cross between robots and Volkswagen Beetles, but deal with the horrific idea of surviving a nuclear holocaust. Bold colors and shiny surfaces display Geiger counters, flashing lights, radiation penetration counters, heating systems, and waste

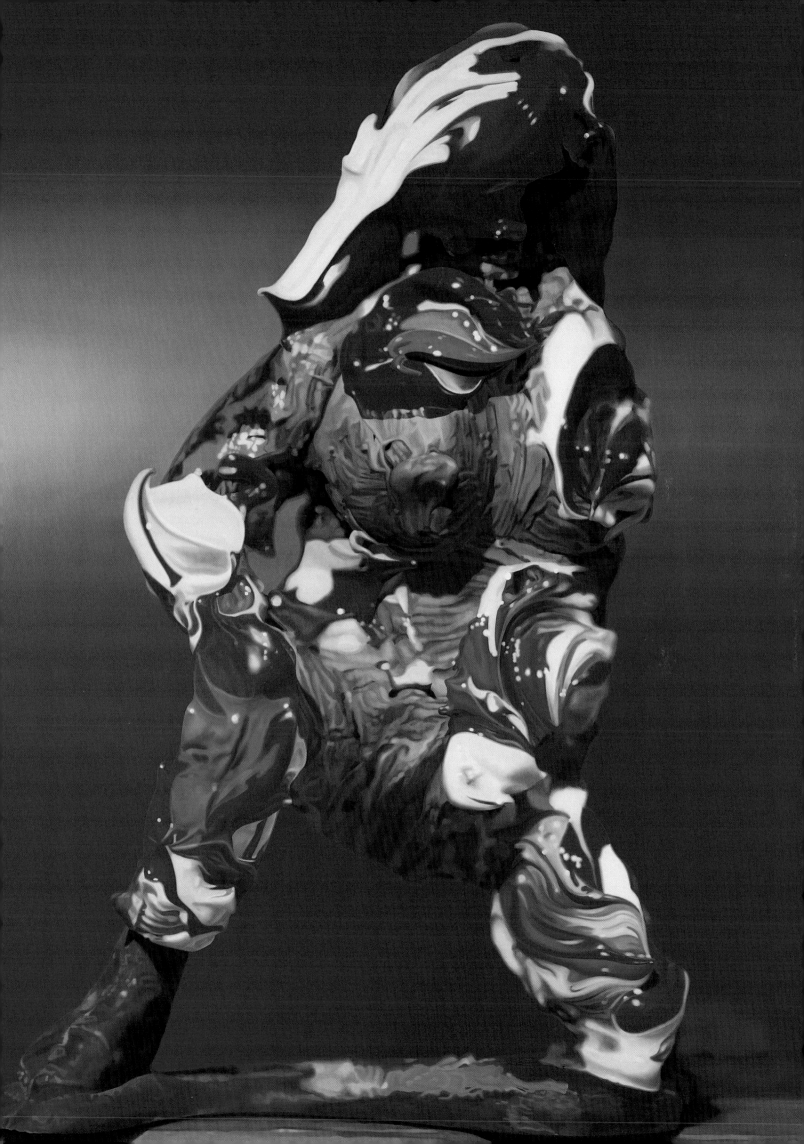

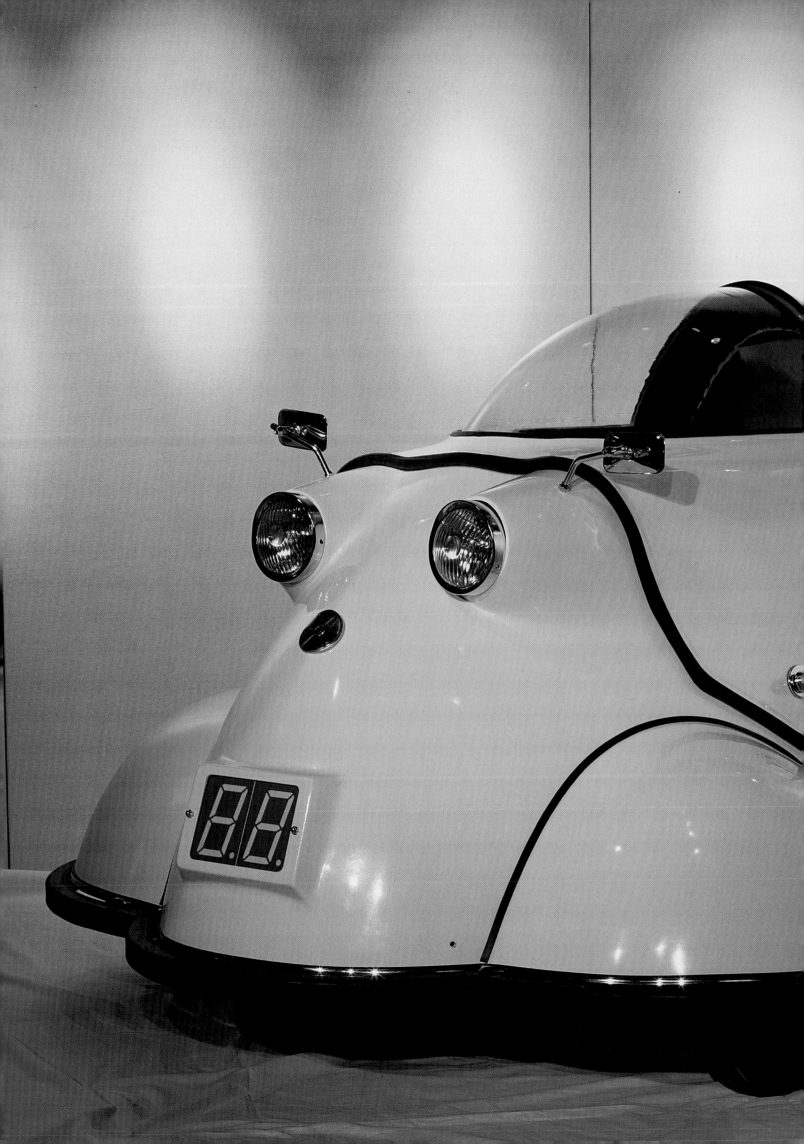

Kenji Yanobe

LEFT **Atom Car, White** 1998

BELOW **Survival Racing Car, Yellow** 1997

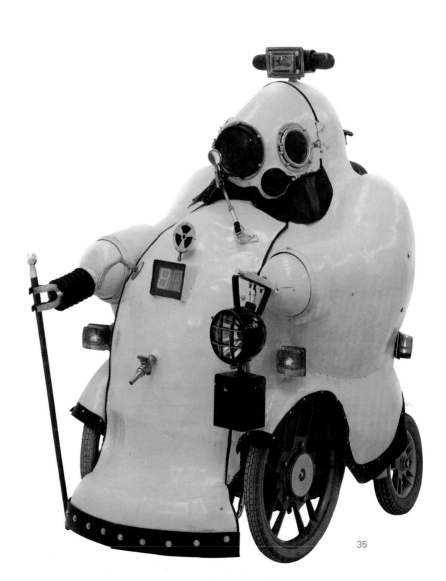

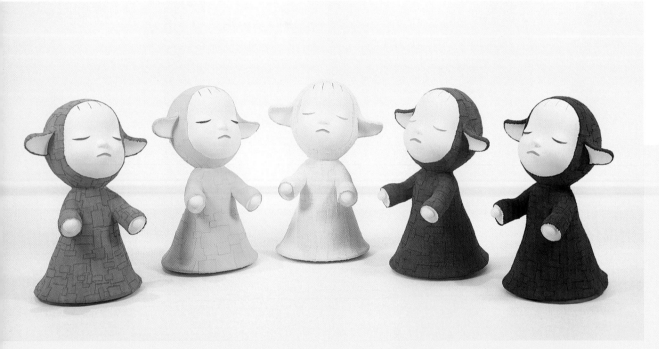

disposals. Both science fiction and cartoon, the cars encapsulate their drivers and provide for their survival. *Astro Boy* was an early influence on Yanobe, as was the playful and futuristic site of the 1970 Japanese World Exposition in Osaka, with its whimsical sculptures by the Japanese artist Taro Okamoto (1911–96). Yanobe's ongoing survival-suit project references the notion of costuming so popular with *anime* fans, and continues the idea of survival, as does *Survival Gacha-pon* (1998), a sculpture recalling a bubble gum machine. The participant places two 100-yen coins in the slot and turns the knob to receive a plastic survival canister, which may contain rice and other forms of subsistence.

Murakami is a pivotal figure in this group of artists, with his astonishing array of paintings, sculpture, film, video, and consumer items. He has created and trademarked a character entitled Mr. DOB, who is drawn from a cartoon monkey popular in Hong Kong but has a kinship with Disney's Mickey Mouse. DOB takes many forms, from inflatable balloons to paintings to sculpture to T-shirts. To produce this array of products Murakami created the Hiropon Factory, modeled

after Andy Warhol's Factory. Like Warhol, Murakami sees the creative process as a communal enterprise reflecting society. Making DOB a capitalist enterprise and attaching it to entertainment and popular culture, he creates his own commercial objects. Yet he takes pride in traditional Japanese painting techniques and formal qualities, such as the flatness of the picture plane and an exquisite use of line and composition.

Murakami has encouraged other Japanese artists to move into the realms of popular culture and entertainment. The idea of play as a survival mechanism corresponds to this merger of entertainment and art in contemporary Japan. Through this process, art, now a corollary to play, enters Japanese society through existing social structures and in a fashion that is familiar in Japanese culture.[11]

Other aspects of *anime* explored by the artists in this exhibition are the notions of cuteness and childishness, evident, for example, in the work of Sachs, McCarthy, and Esber. Through sculptures and paintings of small, childlike entities, Nara depicts and alludes to psychological situations. In *Quiet, Quiet* (1999), the heads of children rise up

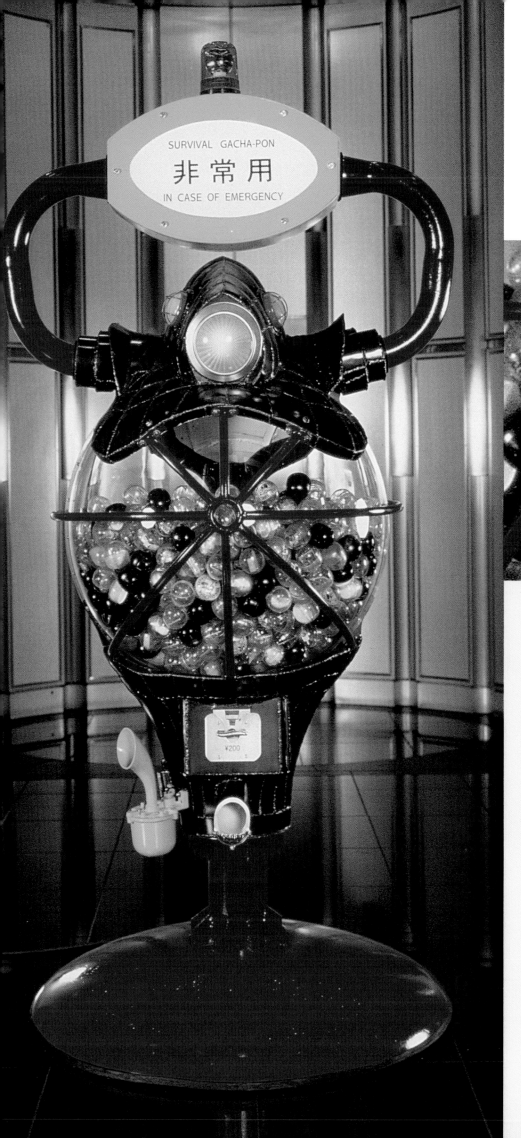

SURVIVAL GACHA-PON

非常用

IN CASE OF EMERGENCY

¥200

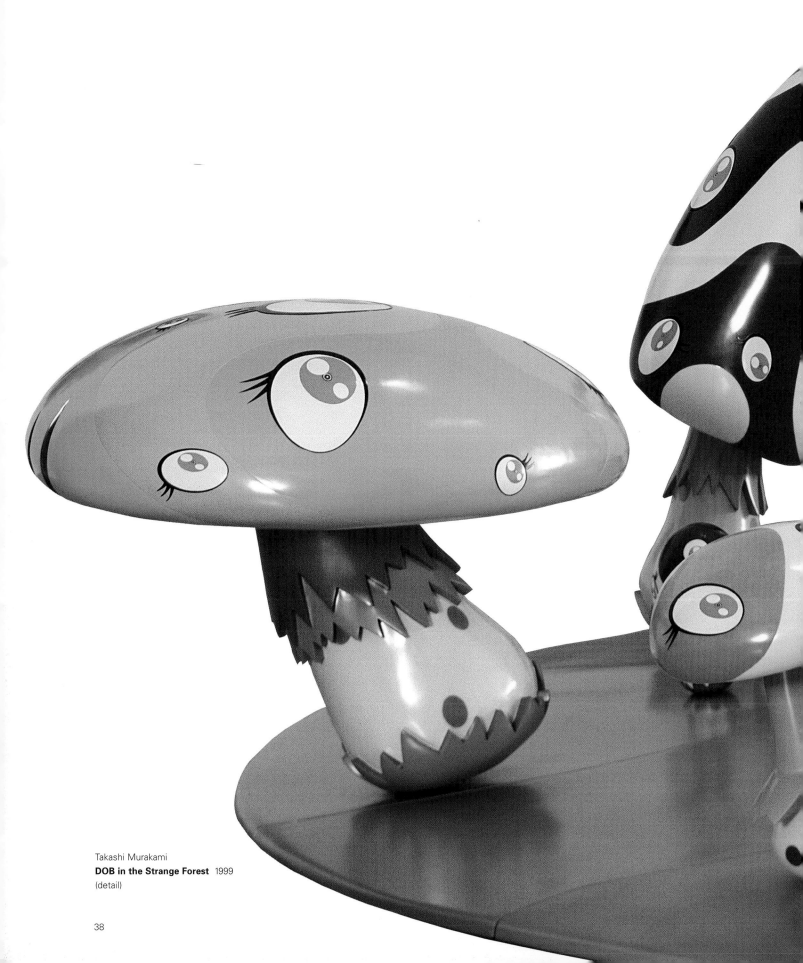

Takashi Murakami
DOB in the Strange Forest 1999
(detail)

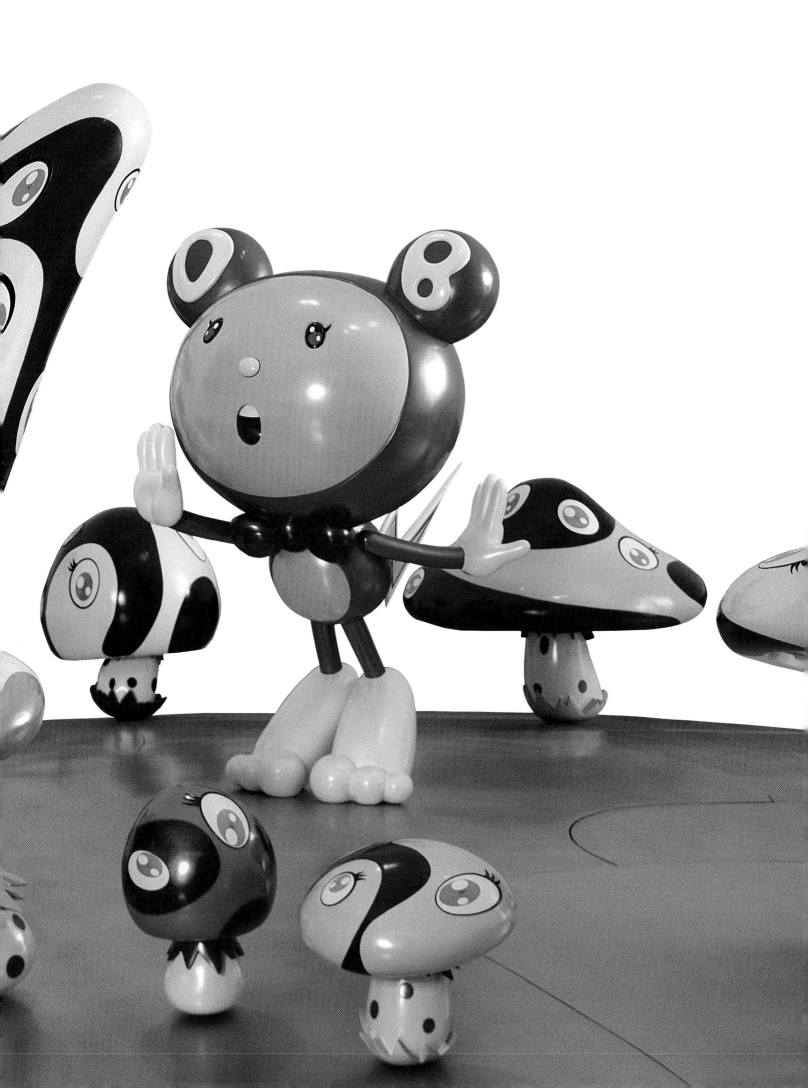

out of the security of a teacup. As with the figures in *The Little Pilgrims (Night Walking)*, their eyes are closed in a dreamlike state. Not seeing the world is a method of escaping it. In *Somehow I Don't Feel Comfortable* (2000), Torimitsu presents two oversized inflatable bunnies, similar to Easter bunnies, pink and feminine, that silently guard the entrance to the exhibition like caryatids crouched under the weight of the ceiling. Through these cute bunnies Torimitsu exaggerates reality beyond the absurd and speaks to the escapism afforded by cuteness. In Japanese mythology the rabbit is the most benign of creatures, totally harmless to humans. These rabbits' large eyes and silly grins emphasize the notion of banality so evident in these objects.

Pardon Me, Miss Snooty Cat[12]

Each of the artists presented here creates an alternative world from a private or communal sense of reality. They derive this world from notions of play that serve as methods of surviving both the present and a dystopian future. Their world is one of freedom and fantasy. This freedom creates an explosion of creative energy that ricochets back and forth across the planet at the speed of light. When observed from space, it must look like an atom surrounded by its electrons and the nebula of atomic matter. The alien invaders don't have a chance.

1. Carl Gustav Horn, "Anime," *Japan Edge: The Insider's Guide to Japanese Pop Subculture* (San Francisco: Cadence Books, 1999), p. 21.

2. Takashi Murakami, "A Theory of Super Flat Japanese Art," *Super Flat*, exh. cat. (Tokyo: Madra Publishing Co., Ltd., 2000), p. 9.

3. See Midori Matsui, "New Japanese Paintings in 1990s," *Painting for Joy: New Japanese Painting in 1990s*, exh. cat. (New York: The Japan Foundation, 1999), p. 10.

4. See Louise Dompierre, "The Age of Anxiety," *The Age of Anxiety*, exh. cat. (Toronto: The Power Plant, 1995), p. 24.

5. See Murakami, "A Theory of Super Flat Japanese Art," p. 17.

6. Hiroyuki Yamaga of Gainax Studio, quoted in Horn, "Anime," p. 22.

7. James Cameron's television series *Dark Angel* presents numerous concepts found in *anime*, for example the powerful young female figure who is destined to save the world. Another television series with a similar heroine, *Buffy the Vampire Slayer*, also seems to be influenced by *anime*.

8. Murakami, "A Theory of Super Flat Japanese Art," p. 17.

9. See Amada Cruz, "DOB in the Land of Otaku," in *Takashi Murakami: The Meaning of the Nonsense of Meaning*, exh. cat. (Annandale-on-Hudson: Center for Curatorial Studies Museum, Bard College, 1999), p. 19. In "A Theory of Super Flat Japanese Art," Murakami discusses six artists from the Edo period and their relationship to contemporary Japanese art: Iwasa Matabei, Kano Sansetsu, Ito Jakuchu, Soga Shohaku, Nagasawa Rosetsu, and Utagawa Kuniyoshi.

10. Murakami, "A Theory of Super Flat Japanese Art," p. 15.

11. See ibid., pp. 21–23.

12. A quotation from Hayao Miyazaki's film *Kiki's Delivery Service* (1989).

RIGHT
Yoshitomo Nara
Quiet, Quiet 1999

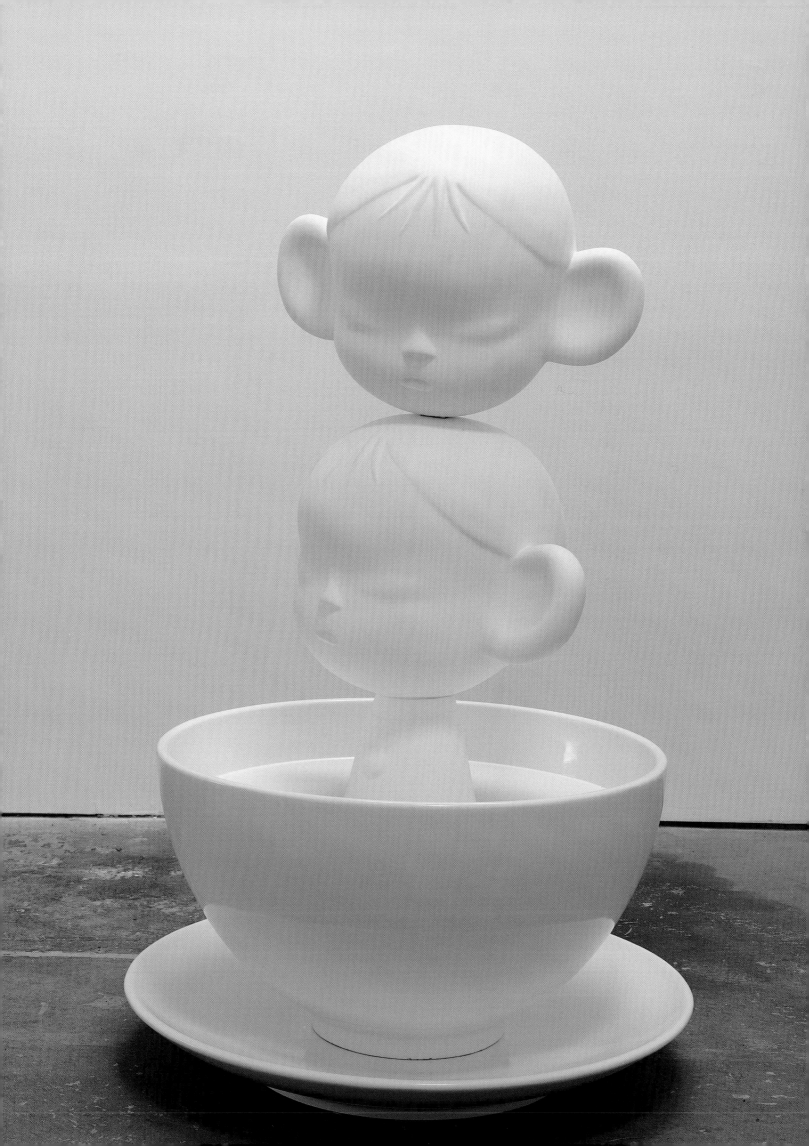

posthuman

MONSTERS and CYBORGS

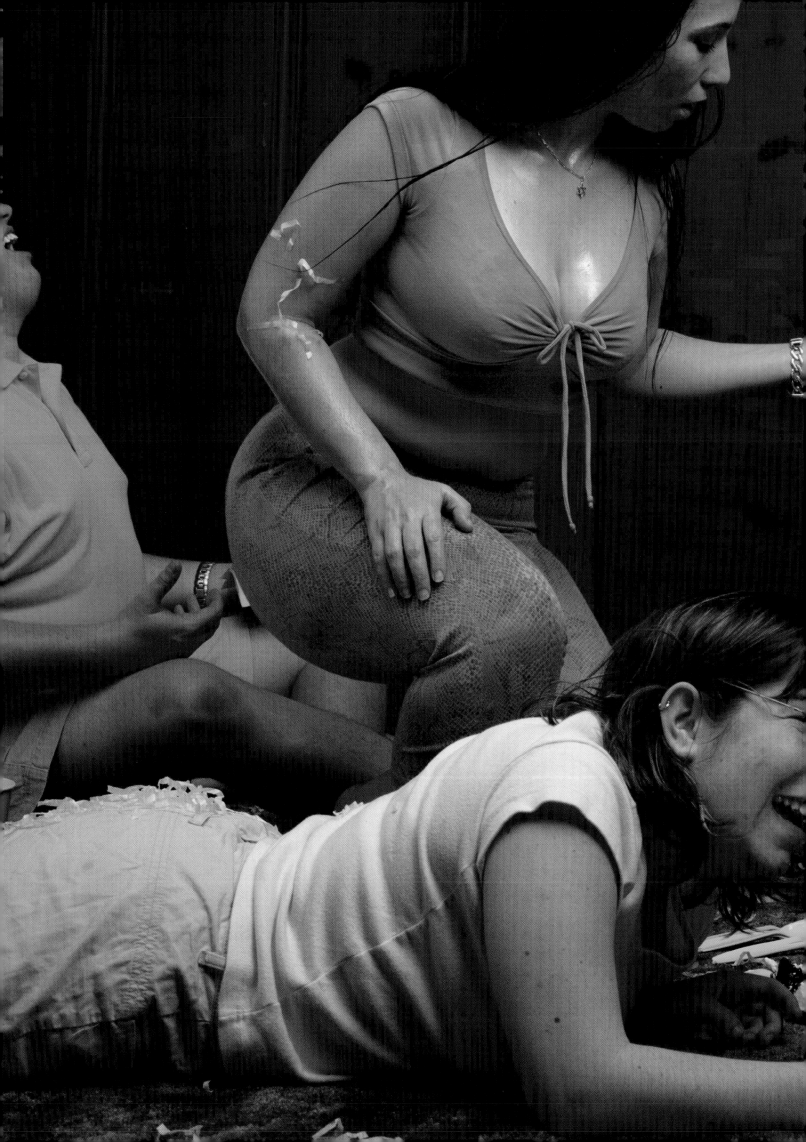

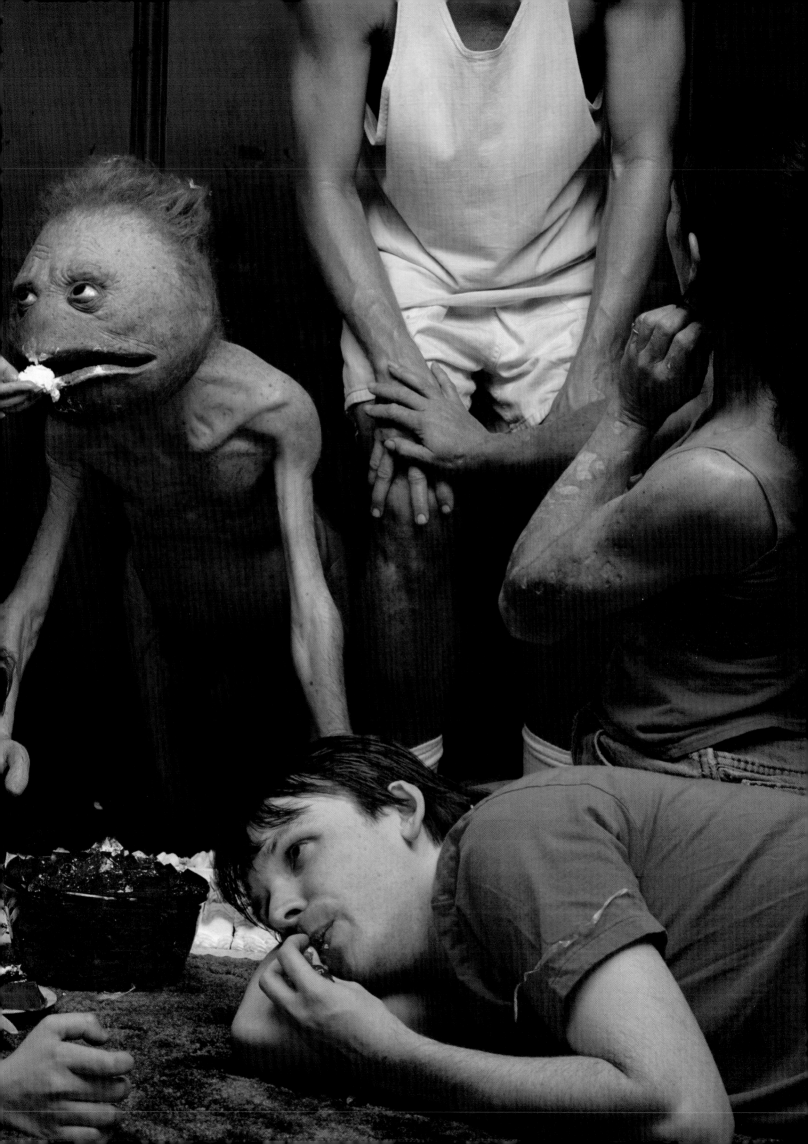

posthuman: monsters and cyborgs

SUSAN LUBOWSKY TALBOTT

A young art dealer from Madrid said in a recent interview, "Our generation is totally posthuman. The only real thing left is sex." Her comment reflects this seminal moment in history, when dramatic changes are impacting the generation that has replaced Generation X. Sherry Turkle, professor of the sociology of science at the Massachusetts Institute of Technology, has described this as "a moment when things are betwixt and between, when old structures have been broken down and new ones have not yet been created. Historically, these times of change are the times of greatest cultural creativity; everything is infused with new meanings."[1]

My Reality: Contemporary Art and the Culture of Japanese Animation presents a group of artists who have embraced this moment. Their creative inspiration is the cultural phenomenon of *anime*, as the Japanese abbreviate animation. *Anime* works are animated films and videos often related to the comics known in Japan as *manga*, and also to the Pokémon games and Hello Kitty toys that obsess children globally. If superheroes are commonplace in conventional comics, a predominant theme in *anime* is their replacement by cyborgs in the posthuman future. The *anime* movement questions traditional moral reasoning in the face of a new technology that blurs distinctions between humans and machines.

Anime is a graphic medium, so it is naturally attractive to young artists who grew up on the *manga* comics and role-playing video games that are now part of comic book culture. Even more important, *anime* addresses contemporary concepts of the human body and our sense of our future as human beings. It has consequently attracted a new generation of artists who teethed on the identity politics of the 1980s and '90s. Questions about sexual identity, which dominated much art of the last decade, have been subsumed into the larger question of what it means to be human. This question is critical to artists Charlie White, Micha Klein, Lee Bul, Mariko Mori, and Matthew Benedict, who created the *anime*-inspired cyborgs and monsters that inhabit *My Reality*.

In the classic *anime* film *Ghost in the Shell* (1995), the heroine, Major Motoko Kusanagi, is a cybernetic being with the body of a robot and a technologically enhanced human mind. Her "shell" is her body, her "ghost" is her soul. Her powers are superhuman, but her sexually idealized physique conceals problems that transcend feminism: the only reason she feels human, she confesses, is that people treat her as if she were. When the villain, who possesses no human brain cells, generates his own "ghost," she asks what is "the importance of being human then?"

Anime-inspired art is the domain of a new generation inwardly preparing for the transition to genetic manipulation, posthuman forms, and the new social structures that will develop to accommodate them. White experiments with these forms and their social implications by building "monsters" with the help of Hollywood special effects technicians. In works such as *Cocktail Party* (2000) and *Ken's Basement* (2000), from his new series "Understanding Joshua," he photographs an eerily lifelike creature in various social settings. Joshua, the recurring character in this series, is a naked monster with distorted human characteristics—long skinny arms and legs, huge hands, webbed feet. His round head has a cartoonlike

RIGHT
Ghost in the Shell 1995
(film still, not in exhibition)

PREVIOUS PAGE
Charlie White
Ken's Basement 2000

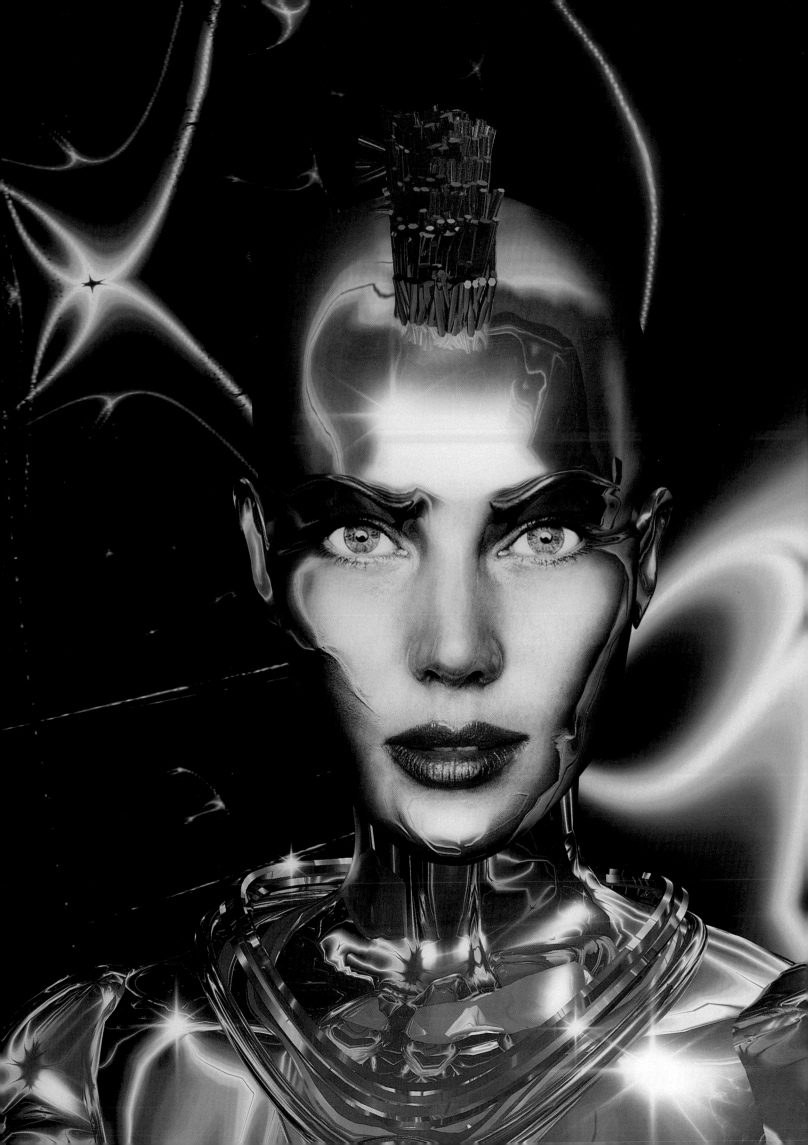

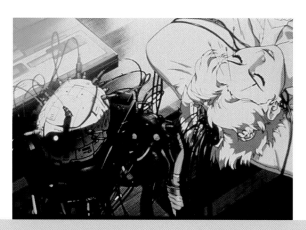

ABOVE **Ghost in the Shell** 1995
(film still, not in exhibition)

LEFT Micha Klein **Virtualistic Vibes, Space Nicky** 1999

similarity to a Muppet. For White he is the manifestation of extreme ontological insecurity, a term coined by the psychologist R. D. Laing to describe a basic uncertainty about one's own being or place in the world. Like Major Motoko, Joshua has no sense of self and doubts the very basis of his existence. And the cocktail party in which White places him is a social system peopled by his unattainable ideal: blond titans who can do everything he can't, like flirt and breed. *Ken's Basement* describes a much more comfortable setting for him—a social situation reminiscent of a preteen party, with unfashionable brunettes sprawled on a fuchsia carpet, eating kid food with their hands. Joshua is fed birthday cake by a buxom young woman, while an overweight young man laughs behind them. Yet even here, in this welcoming atmosphere, Joshua crouches like an animal, revealing his tendency toward victimhood. Perhaps he is a harbinger of the cyborg of the future, a transitional human form who doubts his human characteristics. "*Anime*," says White, "assists in breaking down certain barriers about what the flesh and blood can't do. I take it one step further and create the flesh and blood."

Dutch artist Klein also depicts cyborgs interacting in social situations with humans, but his is a computer-generated world that switches in and out of reality. In *Space Nicky*, one segment of the four-part photographic work *Virtualistic Vibes* (1995–96), "What you see," says Klein, "is a cyborg world in the tradition of Fritz Lang and the Japanese airbrushers. A futuristic world and at the same time a portrait of a generation."[2] *Space Nicky* depicts a beautiful cyborg whose Caucasian face is encased in a hard, plasticlike material and whose

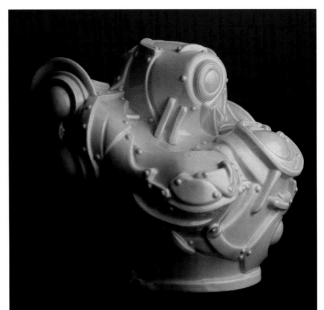

body mutates into a metallic shell. She resembles the *mecha* or armor-clad characters prevalent in *anime*, whose bodies show a kind of powerful exoskeleton. Nicky appears invincible, yet her bright pink lipstick matches that of the very human fashion models in other panels of *Virtualistic Vibes* (not in the exhibition) and roots her in the club culture that Klein inhabits and portrays. *Virtualistic Vibes* was originally conceived as a fashion shoot for the Dutch cult magazine *Wave*, and *Space Nicky* appeared on the magazine's cover. Like Japanese *manga* artists, Klein is a participant in youth culture, and his art is easily accessible in popular commercial formats.

Like Space Nicky, many cyborgs retain their gender but are unable to breed. Since vulnerability is conventionally associated with femininity more than with masculinity, feminine traits serve here as a critical link to humanity. Nicky would appear more robotic without her pink lipstick, as would Major Motoko without her curvaceous form. In the worlds of *manga* and *anime*, females generally have large expressive eyes while males often have black dot eyes. If the eyes are a portal to the soul, then female cyborgs have an advantage over males in the posthuman world, where a soul is a valuable commodity. And with their *mecha* armor, these female characters depend only on their own courage, skill, and intelligence to determine victory in battle. Growing up in Korea in the 1970s and '80s, Bul was immersed in *anime* and *manga* as a child. She recalls the female cyborgs of her youth as ultraviolent, with superhuman powers and girlish characteristics, but usually controlled by a male master. Now Bul creates her own cyborgs as incomplete females missing limbs, organs, and

heads. Like classical Greek and Roman sculpture, these cyborgs invoke archetypal images of women in iconic feminine poses. She describes them as challenges to the myth of technological perfection: "In essence, there is superhuman power, the cult of technology, and girlish vulnerability working in ambiguous concert within this image of the cyborg, and that's what interests me."[3] Bul recently began working in porcelain, a highly vulnerable material, heightening the ambiguity that interests her.

Mori began her career as a model in Japan and now, as an artist, often portrays herself as a cyborg, sometimes dressed in humorous costumes. Like Klein, Mori references pop music, fashion, and club culture in her photographs and videos; like Bul, she focuses on women. Mori's dress-ups share a kinship with the costume or "cos play" events that pervade *anime* culture, making manifest a variant of the *anime* concept of transformation as fans dress in the costumes of favorite *anime* characters. Mori's costumes, however, are of her own invention, even as they evoke the form-fitting outfits of *anime*'s female cyborgs. For her futuristic *Last Departure* (1996), an enormous still photograph from the video installation *Miko no Inori, Link of the Moon*, Mori poses in an angelic white miniskirt outfit with white platform boots and frontal wings that resemble both children's swimming-pool floats and rabbit ears. Her glowing cyborg eyes match the kaleidoscopic crystal globe hovering in space between her cupped hands. Together, the rabbit-ear wings and the globe somewhat resemble the Playboy Bunny logo, a reference to another pop-cultural icon. Photographed at Osaka's Kansai International Airport, *Last Departure* shows Mori surrounded by

Lee Bul
ABOVE
Untitled (Cyborg Torso) 2000
(Des Moines only)
RIGHT
Untitled (Cyborg Leg) 2000

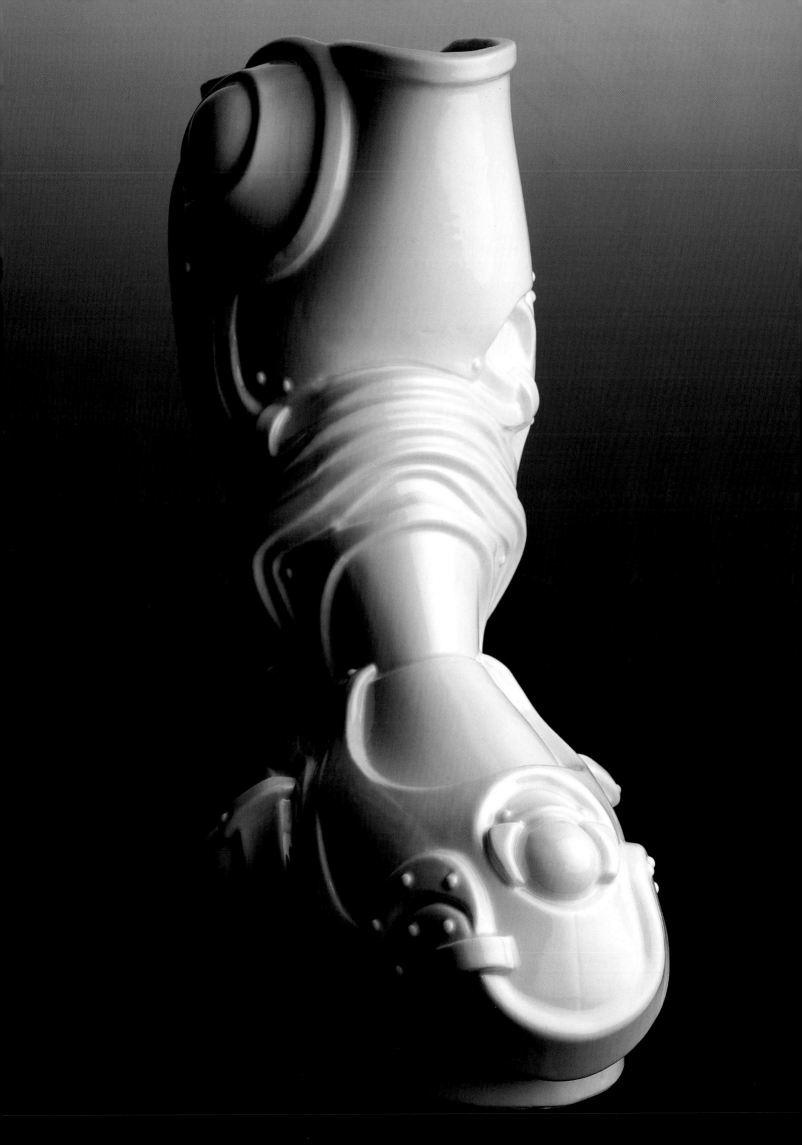

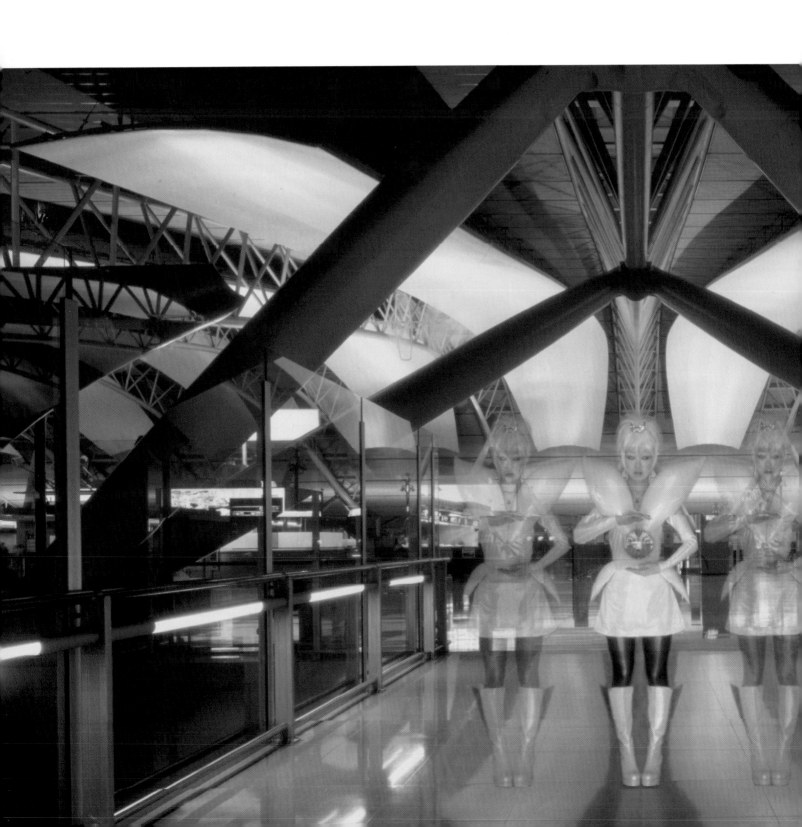

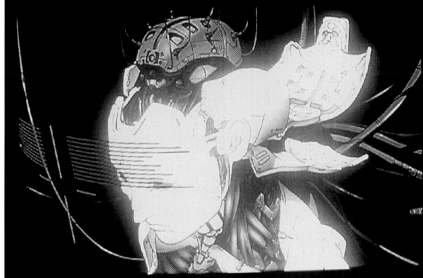

two ghost images of herself—perhaps her ghosts in the shell. The theme of transformation is as familiar in Shinto and Buddhist mythology as it is in *anime*, and in her more recent work Mori directly references these older beliefs of her culture.

The merging of past and future is a typical theme of *anime*, which often weaves Japanese mythology and Western legends into futuristic story lines. Like Mori, Benedict portrays mythic archetypes in the company of cyborgs and other futuristic beings. In *The Trumps* (1998–2000), Benedict uses kitschy figurines and action figures to portray the twenty-two major arcana of the tarot, beginning with the Fool and ending with the Universe. He groups his figures in the order they appear in the tarot deck. Some images, such as Justice and the Sphinx, have endured over time; others, such as the World—traditionally portrayed as a hermaphrodite, and made by Benedict from a gender-bending action figure—are no longer part of our common lexicon. Benedict maintains that the tarot interprets all human relationships and represents all mythic characters. "I'm interested in magic and science being the same thing, and the fact that what was magic in the past is now science."

At the dawn of the posthuman millennium, artists are playing a critical role in reinterpreting the old myths. As social structures are reshaped to cope with advanced technologies, artists help us picture life as it may soon be. Donna Haraway, professor in the History of Ideas Program at the University of California, Santa Cruz, discusses the challenges that face us in her oft-quoted essay "A Cyborg Manifesto: Science, Technology, and Socialist-Feminism in the Late Twentieth Century"

(1991). "The relation between organism and machine," she writes, "has been a border war. The stakes in the border war have been the territories of production, reproduction, and imagination."[4] Inspired by *anime*, artists embrace the future and provide visual guideposts for envisioning it. The artists in *My Reality* empathize with the posthuman condition and likely would agree with the spirit of Haraway's assertion, "I would rather be a cyborg than a goddess."[5]

1. Geri Wittig, " The Body, Post Humans, and Cyborgs: The Influence of Politics of Identity and Emerging Digital and Bio-Technologies on Human Representation in Late 20th Century Art," *Switch* 2, no. 2 (1996): http://cadre.sjsu.edu/switch/narrative/posthuman/posthuman.html.

2. Froukje Hoekstra, "Micha Klein: An Unsettling Virtual World," in *Micha Klein* (Groningen: Groninger Museum and Micha Klein, 1998), p. 9.

3. Hans Ulrich Obrist, "Cyborgs and Silicon: Korean Artist Lee Bul about her Work," *Art Orbit*, no. 1 (1999): www.artnode.se/artorbit.

4. Donna Haraway, "A Cyborg Manifesto: Science, Technology, and Socialist-Feminism in the Late Twentieth Century," *Simians, Cyborgs and Women: The Reinvention of Nature* (New York: Routledge, 1991), p. 150.

5. Ibid., p. 181.

All other quotes are taken from personal interviews with the artists in 2000/2001.

Matthew Benedict
RIGHT **The Trumps** 1998–2000 (detail above)

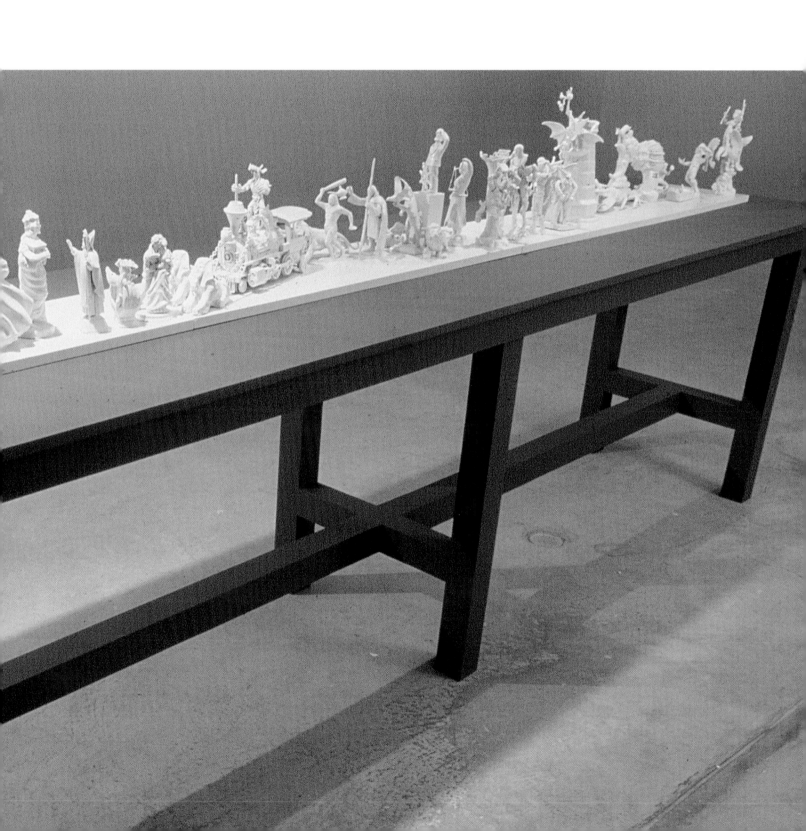

culture—anime

Impotence Culture—Anime

TAKASHI MURAKAMI

Whenever I try to explain what I think about Japanese animation (*anime*), I find myself at a loss. *Anime* has a complex cultural profile. Grasping exactly where it came from, and how it is developing today, is terribly hard.

In the beginning, clearly, *anime* was heavily influenced by American animators such as the Fleischer brothers and Walt Disney, yet it is hard to see this influence in it today. It has developed into a vibrant form unique to Japan, to the point where the word "*anime*" has become a proper noun. Further, *anime's* intertwining connections with other Japanese subcultural genres such as *manga* (comic books) and video games are so deep and complex it is hard to know where to draw the line between one subculture and the other.

In the past several years, many artists, mostly based in Asia, have begun to create *anime*-inspired art. This art responds to the complex milieu of its progenitor in varying degrees. Yet the desire to understand even a part of the deep cultural forest of *anime* is to me, perhaps surprisingly, as pure and creative a motivation as the artistic drive to capture the beauty of a landscape or a nude with the rough tools of the art. Indeed it is a creative motivation I sometimes share. But the modern art scene's desire to understand the subculture of *anime* will not stop with the pure-hearted creation of art. No, we must peel back *anime's* skin, strip away the flesh layer by layer, carve into its bones, and analyze its very marrow before we are satisfied.

Anime productions are released one after another in video games and on television, targeting every age group—*anime* with stunning effects, *anime* on occasion so excessively violent and sexually charged it has become a social problem.

Yet behind the flashy titillation of *anime* lies the shadow of Japan's trauma after the defeat of the Pacific War. The world of *anime* is a world of impotence. I would like to take a look at this creative marrow of impotence, while talking about animators and peculiar developments in the *anime* they make their life's work.

In 1974, the televised *anime* show *Uchusenkan Yamato* (Spaceship Yamato) changed the face of Japanese animation overnight. Fans sprang up everywhere, much like the "trekkies" of *Star Trek*, and a theatrical version of the *anime* was soon produced. The movie was a bigger hit than either the fans or the producers could have dreamed. A sequel was made, and a magazine, *Animage*, was started to cover the phenomenon. The birth of *Animage* sparked today's late-teen *anime* culture, and, it could be said, paved the way for the rise of *otaku* or "nerds," one of the more bizarre facets of Japan's postwar subcultural history. *Animage* examined, analyzed, and discussed *anime* from every possible angle: who are the directors? How is work divided between animators? What shows are the most popular? How does someone become a voiceover actor? Learning from the techniques of *anime* creators, the magazine's readers soon began making their own 8mm animated shorts, critiquing works in the pages of fanzines, and producing parodies. Although at an amateur level, the audience had made a tentative first step upon the stage.

Though the success of *Uchusenkan Yamato* owed a lot to the steady endorsement of its fans, its mixed-media promotion was also remarkable. At the time, late-night radio was the life pulse of youth subculture. The night before the movie release, a live preview drama was broadcast on

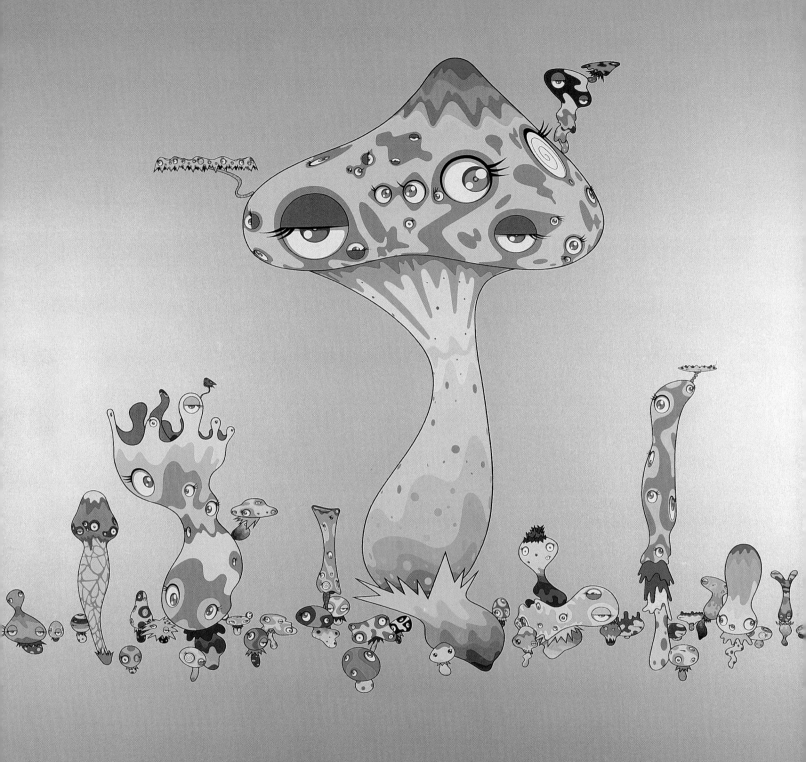

Takashi Murakami **Smooth Nightmare** 2001

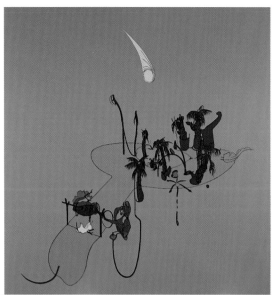

Inka Essenhigh **Cosmos** 1998 (Des Moines only)

All-Night Nippon, one of the most popular radio programs. During this broadcast and also in newspaper articles, it was revealed that movie-goers would receive prints of animation cels (formerly thrown out after a movie was completed) on a first-come-first-serve basis. The night before the film's release, eager fans formed lines to wait for the first screening. The size of the turnout was entirely new.

Through their fanzines and homemade *anime*, these fans had inspired a theatrical remake of a TV series. In their active ability to effect change, they already had far more power than they had possessed before, and possibly even the potential to have more. As more *anime* were released in the hopes of a second *Yamato*, *Animage* took note of this fan activity and launched a campaign to follow fan involvement in the theatrical release of one of these new *anime*, *Kidou Senshi Gundam* (Mobile suit warrior Gundam). Detailed reports followed of high school students, college students, and working people who led *"anime* life-styles" dressing in costumes based on characters in the movie. The night before *Gundam*'s release, like-minded youths gathered in the movie lines, transforming them into a night-long party in honor of the film's director, Yoshiyuki Tomino, and creating dedicated costume players and *otaku*.

Speaking of *otaku*, where did the practice of calling *anime* devotees by this name, which is close to the English word "nerd," come from?

From the beginning there was a crossover between *anime* fans and fans of science fiction in general. Part of the success of *Uchusenkan Yamato* was due to the depth of its setting, replete with science fiction jargon such as "warp drive" and "wave beam" (taken from the original *anime* by

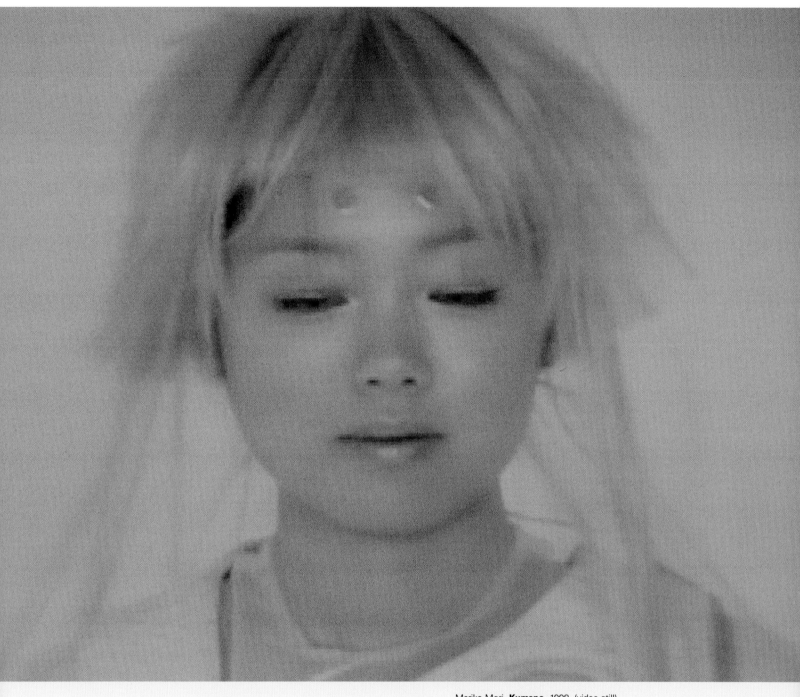

Mariko Mori **Kumano** 1998 (video still)

Leiji Matsumoto). The show's producers had wanted to create a science fiction work of true substance—a dedication that fans appreciated and were even moved by.

Otaku critic Toshio Okada claims that Studio Nue, responsible for assisting with the mechanical designs used in *Yamato*, was the prime origin of all that is *otaku*. Let us take a brief look at this studio, the cradle of *otaku* culture. The first generation of artists at Studio Nue included the science fiction novelist Haruka Takachiho, most famous for his work *Crusher Joe*; Kazutaka Miyatake, the mechanical designer for *Seisenshi Danbain* and other works; the science fiction illustrator Naoyuki Kato; and Ken'ichi Matsuzaki, the scriptwriter for the *Gundam* movie. The second generation at Studio Nue, headed by Masaharu Kawamori and including Haruhiko Mikimoto and others, was responsible for creating *Chojiku Yosai Macross* (Super-dimensional space fortress Macross), truly a product of the *otaku* generation. With the next *Yamato* or *Gundam* as their goal, these two entered the industry and began their professional work while they were still registered as students at Keio University, in Tokyo.

Keio is known as one of the more upstanding and relatively upper-class institutes of learning in Japan. In tune with their somewhat aristocratic surroundings, Kawamori and Mikimoto used the classical, refined second-person form of address, "*otaku*," in preference to "*anata*," the usual form of address. Fans of the studio's work began using the term to show respect toward Studio Nue's creators, and it entered common use among the fans who gathered at comic markets, fanzine meetings, and all-night line parties before major *anime* movie releases. The subculture critic Akio Nakamori later used it derogatorily to refer to *anime* and science fiction fans, who subsequently started referring to themselves that way, half derogatorily, half proudly. Now true *otaku* culture was born. The image of the *otaku* in Japan is that of an overweight, clumsy addict of computer games or other media who groups with like-minded people, all sharing an utter lack of the necessary communication skills that might allow them to relate to the outside world. Cut off in this way, the *otaku* pour all of their energy into the *anime* and *otaku* worlds, showing fervent devotion to successful titles and series and forming a market 1,000,000 strong. (This market is currently swelling to a sizeable 20,000,000 people.)

In addition to Tomino, director of *Gundam*, other well-known creative talents in the *anime* industry include Miyazaki Hayao, the director of *Tonari no Totoro* (My neighbor Totoro); Mamoru Oshii of *Ghost in the Shell* fame; and Hideaki Anno, the creator of the television and movie series *Evangelion*. Anno was a member of the first generation of self-aware *otaku*. At the time, he was a student at the Osaka University of Art, surrounded by people joined in an almost conspiratorial devotion to creating more *otaku*. His fellow alumni include, first, Toshio Okada, originally an *otaku* critic who later became the driving force behind the creation of the venture animation-production company Gainax. Second might be Yamaga Hiroyuki, the director of that company's first theatrical release, *Oritu Uchugun—Honneamise no Tsubasa* (The wings of Honneamise). Another is Takami Akai, the character designer for the game Princess Maker, where

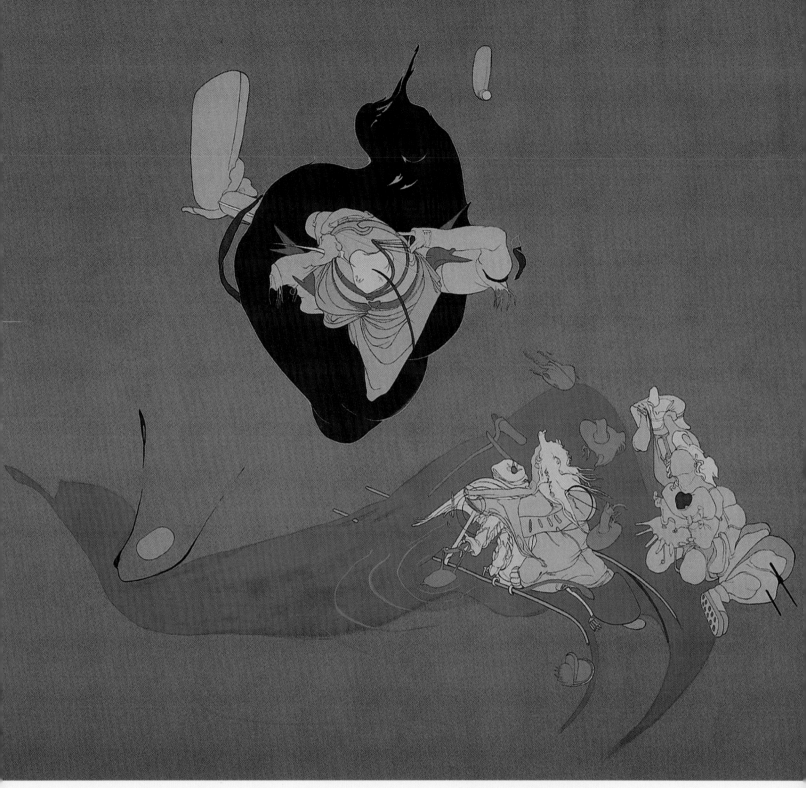

Inka Essenhigh **The Adoration** 1998

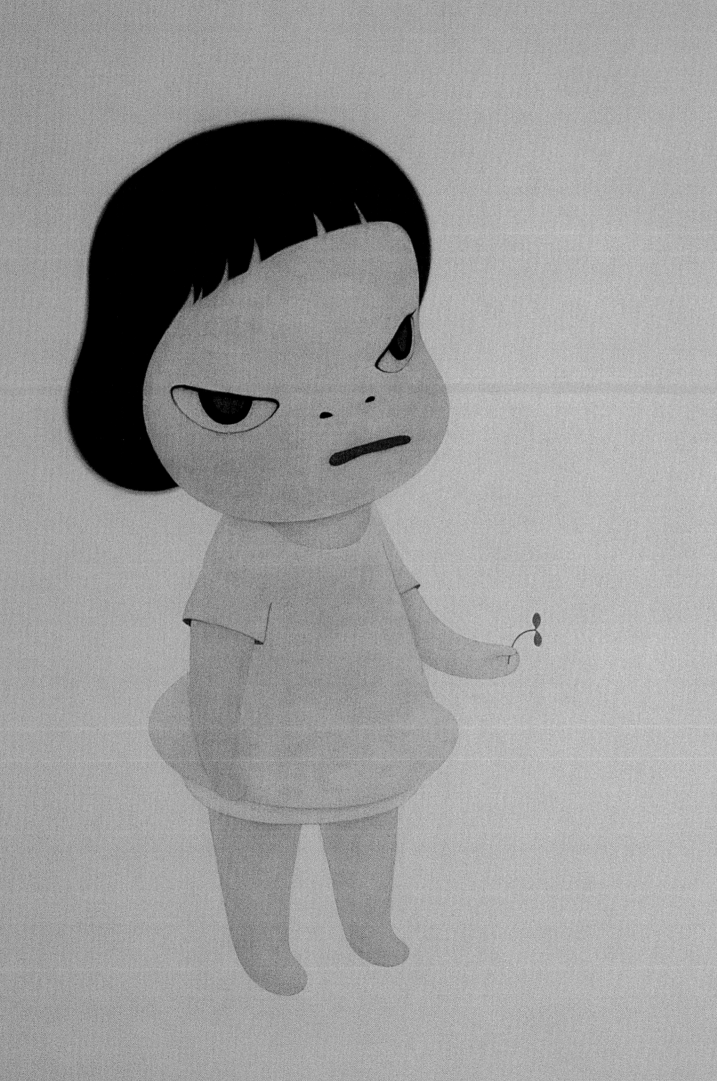

players create and virtually raise a girl to become a princess. This game has been a record-breaking hit for Studio Gainax. In addition to these three, many other core members of the company who wore the crown of *otaku* and chose animation as their artistic medium got their start doing amateur work at the same university. This, then, all leads to the now legendary science fiction convention DAICON.

DAICON is the Osaka installment of a traveling exhibition that moves throughout the country each year. Based on similar conventions in the U.S., the exhibition attracts science fiction fans from across the country, filling up hotels, participating in stage events and panel discussions, dressing up as their favorite characters, holding all-night video screenings, and selling fanzines on the exhibition floor. The first convention opening ceremony into which Anno and his staff poured all their effort was the opening animation for DAICON 3, in 1990. The animation, clearly well above amateur creations in its level of quality, was received with the highest praise by the audience of fans. No standard media had been set for the opening show in previous years, but the impact of this presentation established the tradition of an opening animation at every DAICON.

The opening animation at DAICON 4, in 1991, was a distillation of all that was *otaku* at the time into an 8mm animated movie just under five minutes in length. Hiroyuki and Anno had gone to Tokyo to participate as staff on Studio Nue's production of *Chojiku Yosai Macross*. Returning to Osaka, they directed all the know-how they had gained during that time into making this opening movie, remarkable for its decidedly nonamateurish concept, composition, technique, and exceptional

quality. Combining science fiction themes, live action, and *anime*, it was a kind of catalog of "symbolic *otaku* elements" presented tongue-in-cheek to an enthusiastic audience of *anime* and *otaku* fans. Akai also brought the *otaku* in the audience live, Lolita-faced girls dressed in bunny girl suits.

The movie was a work of storytelling, drawing the audience into the world of the *otaku*. A particularly memorable scene was a hand-drawn animated copy of a famous archive film of an A-bomb test carried out by the U.S. military. This scene had played over and over throughout the '70s on Japanese television. In the original film, a small house is shown being hit by a shock wave from the explosion and blowing into bits. In the DAICON 4 version, however, the explosion takes place in a familiar cityscape somewhere in Japan. In the wake of an explosion that sends buildings disintegrating and flying, green trees miraculously spring up from the earth. Then, on the land now covered with green, innumerable sci-fi characters gather together for a grand finale. This experimental image combined *otaku* sexuality, tastes, and a final catharsis all in one package. The scene of the explosion and shock wave already existed—the staff had made it for use in *Chojiku Yosai Macross*, and similar scenes appeared in Gainax's later commercial animated films. In a sense, the oft-maligned *otaku* of Japan had managed to retain an understanding of the trauma of Japan's defeat in World War II, albeit an understanding encased in the easily digestible gel capsule of science fiction. In other words, the opening animation at DAIKON 4 was a self-portrait of the *otaku* and, at the same time, an honest, indeed naked self-portrait of the defeated citizens of Japan.

In hindsight we can clearly see that *Uchusenkan*

RIGHT **Dragon Ball Z** (video still, not in exhibition)

Yamato is a story of the resurrection of the warship *Yamato*, sunk during World War II before it even joined battle. *Gundam*, too, a story of the birth of a human "newtype" with superpowers in the wake of a space war, gave the *otaku* a dream to follow, and provided a sort of psychological escape zone for defeated spirits by equating the newtypes with postwar Japanese. These core *otaku* works remain a considerable influence today.

Japan—a country weakened, made impotent in its defeat. The more *anime* has attempted an honest understanding of this impotence, the more ripples it has caused, and the more the *otaku* have been shunned within Japanese society. Neither the *otaku* nor the *otaku*-haters realize that these works are merely a form of self-portraiture. No, they actively don't want to realize it.

Is this the same as or the opposite of famous American cartoonists who pull characters, so enduring in the world of today, from the nightmare of drug addiction? Nowadays, even *otaku* culture has produced several characters that can compete with American cartoon icons on equal footing.

The pillars of Japan's postdefeat culture of impotence, *otaku* and *anime* rely on that rich soil and (unlike Disney) the dark side of dreams-made-real. With these as their weapons, they have seized an enormous entertainment market and are developing into a deep cultural forest, attracting and enticing even fine artists with its potential. *Otaku* and *anime* have been appropriated as a Disneyesque escape mechanism from reality. Yet they continue, and will continue in the future, to grow as a culture of impotence.

Written with research assistance from Ryusuke Hikawa.

glossary

Scene from the TV show **Dragon Ball Z,** a classic example of *anime*

Anime Japanese animation films or animation in the Japanese style. The word *"anime"* was adopted by the Japanese from the French word for animation. It was then adopted by Americans to describe the unique type of animation that comes from Japan. The *anime* industry is much like the American film industry, producing films in various genres and for all age groups.

Bishonen Literally means "beautiful boy." *Bishonen manga* are stories about beautiful young men in love with each other. They are not produced for a gay audience, but for young women. *Bishonen* is also used as an adjective for any male character who is portrayed as more beautiful than handsome.

CosPlay Short for "Costume Play." A costume contest or masquerade in which fans dress as their favorite *anime* characters, sometimes reenacting scenes from specific films. These events are held at *anime* conventions and are extremely popular.

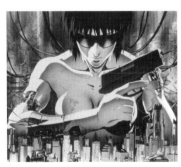

A female cyborg in **Ghost in the Shell**

Cyborg A human being whose body has been taken over in whole or in part by electro-mechanical devices; a bionic man or woman. *Cyborgs* are quite common in *anime*, particularly female *cyborgs*.

Examples include *Ghost in the Shell* and *Battle Angel*.

Fan-sub *Anime* that is subtitled by fans. The *anime* is imported from Japan, translated, subtitled, and then distributed. This is all unauthorized, done by people on their own time, as an act of (near religious) devotion. Once *fan-subs* are produced they can be copied freely, and to relieve the strain on the few main sources, most people get second or later generation copies from the huge network of people involved in copying and trading them. Since copies are usually distributed for free, many *fan-subbers* believe what they do is morally right, but they are actually violating copyright law.

Japanimation American slang for Japanese animation. Similar to other less than ideal terms like "blaxsploitation" or "teensploitation." It is considered best to use the full "Japanese animation" or *"anime."*

Kami Usually translated as the Shinto word for god or goddess, although the actual meaning is closer to "spirit" or "soul." Can also be used as a term of greatest respect, e.g. the great artist Osamu Tezuka is often referred to as *manga no kami*, the *manga* god.

Kawaii Cute, delightful, or pretty. Cuteness is a characteristic of great importance in some *anime*.

Viz Graphic Novel (*manga*), story and art by Rumiko Takahashi

Manga Japanese comic books or graphic novels. They often begin as serialized entries in monthly magazines. If they are popular, they are collected into books or series of books. Most *anime* are based on popular *manga*.

Mecha or **Mech** the Japanese fascination with all things mechanical finds it way into a lot of *anime*. *"Mecha"* is the Japanese derivation of "mechanical" and loosely refers to any and all cool pieces of technology. The term *"mech"* is largely reserved for the large humanoid robots that battle it out in a myriad of sci-fi *anime*.

Miyazaki, Hayao Born in 1941 in Tokyo, Miyazaki is considered Japan's premier animator. His films, which include *My*

Neighbor Totoro, Kiki's Delivery Service, and *Princess Mononoke*, are cultural institutions in Japan, with *Mononoke* being the highest grossing domestic film in Japanese history. Miyazaki is renowned as a master storyteller, with each of his films creating its own unique universe. Visually, his films have a distinctly handcrafted, organic look, a testament to the fact that Miyazaki rarely uses computer-generated imagery, and personally draws the majority of individual frames of his movies.

Otaku An *anime* fan. The term literally means "you" in a very formal sense. In Japan, it has come to mean people who are obsessed with something to the point where they have few close personal relationships. The nature of the obsession can be anything from *anime* to computers. In Japan, *otaku* has the same negative connotation as "nerd." In America, however, it refers specifically to hardcore *anime* fans, without any negative connotation.

Shinto Japan's indigenous religion. The word literally means "the way of the gods." Shinto contains over 8 million gods or *kami*, and even more stories. A lot of *anime* is based on Shinto mythology and folklore.

Shojo Japanese for girl. *Shojo manga* are targeted toward a young female audience and are drawn in a very flowery, pretty, romantic style, and deal with mainly romantic or emotional subjects. *Shojo anime* is not specifically for women but emphasizes emotions and personal relationships.

Shonen Japanese for boy. *Shonen manga* and *anime* are often more action-adventure oriented, with the notable exception of *bishonen* (beautiful boy *manga*).

Tezuka, Osamu (1928–1989) Often referred to as the "God of Manga," Osamu Tezuka is credited with revolutionizing and in some ways inventing the Japanese comics industry. Heavily influenced by Disney animation (*Bambi* in particular), Tezuka's style of drawing *manga* (comics) concentrated less on dialogue and more on visual conventions, particularly movement. He is also credited with introducing the large, expressive eyes that have become a trademark of Japanese animation. In 1961, Tezuka set up an independent animation company to produce his landmark series *Tetsuwan Atumo*. This series, renamed *AstroBoy,* would become the first *anime* ever to be aired in America.

Definition information taken from:
Levi, Antonia, *Samurai from Outer Space: Understanding Japanese Animation*, Open Court, Chicago, Illinois, 1996 www.tapanime.com www.cs/mun/ca/~anime/afs/animdict.html (St. John's Anime Film Society)

RIGHT Video still from **Sailor Moon,** a classic example of *anime*

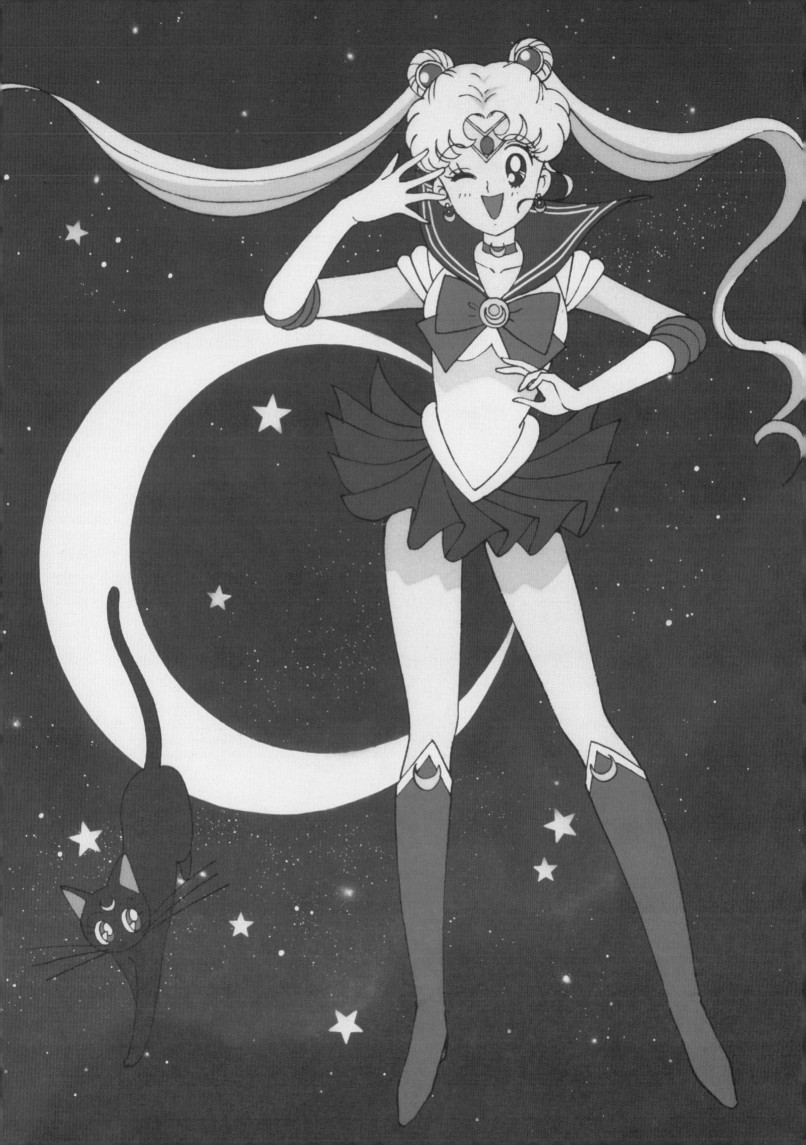

works in the exhibition

Matthew Benedict Born 1968, United States

The Trumps, 1998–2000
Plastic, metal, ceramic, plaster, latex, and enamel
13 1/2 x 10 x 120 inches
Courtesy of the artist and Alexander and Bonin, New York

Lee Bul Born 1964, South Korea

Gravity Greater Than Velocity II, 1999
Mixed media with sound
84 1/2 x 49 x 72 1/4 inches
Courtesy of the artist and PKM Gallery, Seoul, South Korea

Untitled (Cyborg Pelvis), 2000
Porcelain with wood and glass display case
13 1/2 x 13 1/2 x 13 1/2 inches, edition 2/3
Courtesy of the artist and PKM Gallery, Seoul, South Korea

Untitled (Cyborg Leg), 2000
Porcelain with wood and glass display case
21 x 9 3/4 x 16 3/4, edition 2/3
Courtesy of the artist and PKM Gallery, Seoul, South Korea

Untitled (Cyborg Torso), 2000 (Des Moines only)
Porcelain with wood and glass display case
Overall 67 x 24 x 24 inches
Object 12 1/2 x 15 3/4 x 11 3/4 inches, edition 3/3
Courtesy of the artist and PKM Gallery, Seoul, South Korea

Taro Chiezo Born 1962, Japan

Angry Girl, 1996
Oil, acrylic on board
79 x 63 inches
Courtesy of the artist and Sandra Gering Gallery, New York

Lamb Bananas, 1994
Acylic on FRP with Robotic mechanism
Six at 18 x 22 x 7 1/2 inches each
Courtesy of the artist and Sandra Gering Gallery, New York

James Esber Born 1961, United States

Mon Mon 2, 1997
Plasticine on canvas
108 x 42 inches
Courtesy of the artist and P.P.O.W., New York

Inka Essenhigh Born 1969, United States

Cosmos, 1998 (Des Moines only)
Oil and enamel on canvas
76 x 74 inches
Collection of Neuberger Berman, New York

The Adoration, 1999
Oil and enamel on canvas
72 x 76 inches
Collection of Barbara Schwartz, New York

Supergod, 2000
Oil and enamel on canvas
72 x 74 inches
Collection of Glenn Scott Wright, London; courtesy of the
artist and Victoria Miro Gallery, London

Mika Kato Born 1975, Japan

Sun Rise, 1999
Oil on canvas
50 1/4 x 47 1/8 inches
Collection of Saito Kazunori; courtesy of Tomio Koyama
Gallery, Tokyo Japan

Micha Klein Born 1964, The Netherlands

Virtualistic Vibes, Space Nicky, 1996
C-Print, Perspex, and wood
59 x 47 inches
Courtesy of the artist and Robert Sandelson, London

Miltos Manetas Born 1964, Greece

Flames I, 1997
Video
2 minutes
Courtesy of the artist

Flames II, 1997
Video
5 minutes
Courtesy of the artist

I am Sorry, 1997
Video
1 minute
Courtesy of the artist

Videoday, 1997
Video
60 minutes
Courtesy of the artist

Paul McCarthy Born 1945, United States

Dwarf Head, 2000 (Des Moines only)
Platinum-based silicone
16 x 15 x 16 inches
Collection of Paul and Estelle Berg, Miami, Florida

Dwarf Head, 2000
Platinum-based silicone
16 x 15 x 16 inches
Courtesy of Marc Jancou Fine Art, New York

Dwarf Head, 2000
Platinum-based silicone
16 x 15 x 16 inches
Courtesy of John Berggruen Gallery, San Francisco, California

Mariko Mori Born 1967, Japan

Kumano, 1999
Video
13 minutes 27 seconds
Courtesy of the artist, Deitch Projects, New York, and
Gallery Koyanagi, Tokyo, Japan

Last Departure, 1996
Cibachrome print, aluminum, wood, smoke chrome
aluminum frame
84 x 144 x 3 inches
Collection of Eileen and Peter Norton, Santa Monica, California

Mr. (Masakatu Iwamoto) Born 1969, Japan

Venus #2, 2001
Ink on paper receipts
Variable dimensions
Collection of Mr. and Mrs. Breck Kling, New York;
courtesy Vedanta Gallery, Chicago, Illinois

Takashi Murakami Born 1962, Japan

DOB in the Strange Forest, 1999
FRP resin, fiberglass, and acrylic
60 x 120 inches in diameter
Collection of Eileen and Peter Norton, Santa Monica, California

Smooth Nightmare, 2001
Acrylic on canvas mounted on wood
63 x 63 inches
Speyer Family Collection; courtesy of Marianne Boesky
Gallery, New York

Yoshitomo Nara Born 1959, Japan

The Little Pilgrims (Night Walking), 1999
(Des Moines only)
Fiberglass, acrylic, and cotton
Five at 28 x 19 x 19 inches each
Collection of Sue Hancock, Florida; courtesy of Blum & Poe,
Santa Monica, California

Quiet, Quiet, 1999
Fiberglass, resin, and lacquer
56 x 37 x 37 inches
Courtesy of the artist and Blum & Poe,
Santa Monica, California

Little Ambassador, 2000
Acrylic on canvas
78 x 52 inches
Collection of Lisa Kenney; courtesy of Blum & Poe,
Santa Monica, California

Richard Patterson Born 1963, Great Britain

Three Times a Lady, 1993
Oil on canvas
82 x 57 inches
Collection of Josef W. Froehlich, Stuttgart, Germany;
courtesy of James Cohan Gallery, New York

Tom Sachs Born 1966, United States

Lost in the Wilderness, 2000–01
Refrigerator on its side, electric lights, foam core,
and stereo equipment
54 x 75 x 31 inches
Courtesy of Mary Boone Gallery, New York

Super Dynamite Soul, 1998 (Des Moines only)
Paper and table
54 x 33 x 39 inches
Collection of Gian Enzo Sperone, New York;
courtesy of Sperone Westwater, New York

Momoyo Torimitsu Born 1967, Japan

Somehow I Don't Feel Comfortable, 2000
Rubber (inflatable balloons)
Two figures at 16 x 10 feet in diameter
The Dikeou Collection, Denver; (Exhibition copy for tour courtesy
of the artist and Galerie Xippas, Paris, France)

Charlie White Born 1972, United States

The Cocktail Party, 2000
Light jet chromogenic print mounted on plexiglass
36 x 60 inches
Courtesy of the artist and Andrea Rosen Gallery, New York

Ken's Basement, 2000
Light jet chromogenic print mounted on plexiglass
36 x 60 inches
Courtesy of the artist and Andrea Rosen Gallery, New York

Kenji Yanobe Born 1965, Japan

Atom Car, White, 1998
Gieger counter, FRP resin, motor, and mixed media
43 3/4 x 59 x 82 3/4 inches
Courtesy of the artist and Rontgen Kunstraum, Tokyo, Japan

Survival Gacha-pon, 1998
Steel, 1000 survival goods capsules, and mixed media
108 1/2 x 51 x 45 1/2 inches
Courtesy of the artist and Rontgen Kunstraum, Tokyo, Japan

Survival Racing Car, Yellow, 1997
Wheel chair, motor, FRP resin, and mixed media
55 x 41 1/4 x 55 inches
Babilonia Wilner Collection, Berkeley, California

ARTIST BIOGRAPHIES

MATTHEW BENEDICT

Born 1968, Rockville, Connecticut
Lives and works in New York

Education

1986–87 School of the Art Institute of Chicago
1987–88 Alliance of Independent Colleges of Art,
 New York Studio Program
 B.A., Eugene Lang College, The New School
 for Social Research, New York

Selected Solo Exhibitions

2000 *Matthew Benedict,* Alexander and Bonin, New York
1998 *The Magus and other Tales,* Alexander and Bonin,
 New York
1996 *Salvation,* Statements at Basel 27 (presented by
 Mai 36 Galerie, Zurich)
1995 *The Brotherhood,* Brooke Alexander, New York
 Matthew Benedict, Janice Guy, New York
1993 *SAINTS,* Project for the windows of the Grey Art
 Gallery and Study Center, New York University

LEE BUL

Born 1964, Yongwul, Korea
Lives and works in Seoul

Education

1987 B.F.A., Sculpture, Hong Ik University, Seoul

Selected Solo Exhibitions

2001 Fabric Workshop and Museum, Philadelphia
 San Francisco Art Institute, San Francisco
 SCAI, The Bathhouse, Tokyo BAWAG Foundation,
 Vienna
2000 Fukuoka Asian Art Museum, Fukuoka, Japan
 Kukje Gallery, Seoul
1999 Korean Pavilion, Venice Biennale
 Kunsthalle, Bern Projektraum, Bern, Switzerland
1998 Artsonje Center, Seoul
1997 *Projects,* Museum of Modern Art, New York

Selected Group Exhibitions

2001 *Egofugal,* 7th International Istanbul Biennial
 01.01.01: Art in Technological Times, San
 Francisco Museum of Modern Art, San Francisco
2000 *Au delà du spectacle,* Centre Georges
 Pompidou, Paris

Shanghai Biennale, Shanghai Art Museum
media_city seoul, Seoul Metropolitan Art Museum,
 Seoul
Lust Warande, De Oude Warande
Echigo-Tsumari Art Triennial, Echigo-Tsumari, Japan
Air Air, Grimaldi Forum, Monaco
Tourlou, tourlou, Melina Mercouri Art Space,
 Hydra, Greece
Continuum 001, CCA Glasgow, Scotland
Let's Entertain, Walker Art Center, Minneapolis;
 travels to Portland Art Museum, Portland,
 Oregon; Centre Georges Pompidou, Paris;
 Museo Rufino Tamayo, Mexico City; St. Louis
 Art Museum, St. Louis; and Miami Art Museum,
 Miami
1999 *Cities on the Move 7,* Kiasma Museum of
 Contemporary Art, Helsinki
 Der anagrammatische Körper, Kunsthaus
 Muerz in cooperation with Neue Galerie Graz
 Austria; traveled to Zentrum für Kunst and
 Medientechnologie, Karlsruhe, Germany
 La casa, il corpo, il cuore, Museum Moderner
 Kunst Stiftung Ludwig, Vienna, and National
 Gallery, Prague
 DaPERT Tutto, Venice Biennale
 Hot Air, Granship Center, Shizuoku, Japan
1998 *Sarajevo 2000,* Museum Moderner Kunst Stiftung
 Ludwig, Vienna
 Slowness of Speed, National Gallery of Victoria,
 Melbourne; Art Gallery of New South Wales,
 Sydney; and Artsonje Center, Seoul
 The Natural World, Vancouver Art Gallery, Vancouver
 Hugo Boss Prize 1998, Guggenheim Museum,
 New York

TARO CHIEZO

Born 1962, Tokyo
Lives and works in New York and Tokyo

Education

1980–84 New York University, Tisch School of the Arts,
 New York

Selected Solo Exhibitions

2000 *Day Dream,* Kohji Ogura Gallery, Nagoya, Japan
 Sandra Gering Gallery, New York
 Public Ghost: Paintings 1996–1999, Dai-ichi

Life Gallery, Tokyo

Public Ghost: New Paintings 1999, Tomio Koyama Gallery, Tokyo

1997 *Robot Love,* Kirin Art Space Harajuku, Tokyo

1996 *Between Life and Death,* Ginza Komatsu, Tokyo

1994 *The Edge of Chaos,* Sandra Gering Gallery, New York, and SCAI, The Bathhouse, Shiraishi Contemporary Art, Inc., Tokyo

1993 Sandra Gering Gallery, New York

1992 Mars Gallery, Tokyo

Selected Group Exhibitions

1999 *Sampling,* Ronald Feldman Gallery, New York

Painting for Joy: New Japanese Painting in the 1990s, Japan Foundation Forum, Tokyo

1998 *The Manga Age,* Museum of Contemporary Art, Tokyo

Presumed Innocence, Anderson Gallery, Richmond, Virginia, and Contemporary Arts Center, Cincinnati

1997 *Heaven-Private View,* P.S.1 Contemporary Art Center, Long Island City, New York

Super Body, Tomio Koyama Gallery, Tokyo

TOKYO POP, Hiratsuka Museum of Art, Hiratsuka, Japan

Intangible Childhood, Mie Prefectural Art Museum, Tsu, Mie Ideal Standard Life, Spiral, Tokyo

1995 *Age of Anxiety,* The Power Plant, Toronto

Osaka Triennial 1995, Mydome Osaka, Japan

1994 *Arrested Childhood,* Center for Contemporary Art, North Miami

JAMES ESBER

Born 1961, Cleveland, Ohio

Lives and works in New York

Education

1982 Studio Art Centers International, Florence

1983 Temple University Abroad, Rome

1984 B.F.A, Cleveland Institute of Art, Cleveland

1984 Skowhegan School of Painting and Sculpture, Skowhegan, Maine

Selected Solo Exhibitions

2000 P.P.O.W. Gallery, New York

1998 P.P.O.W. Gallery, New York

1997 Pierogi 2000, Brooklyn

1996 Herter Art Gallery, University of Massachusetts, Amherst

1992 Hudson D. Walker Gallery, Provincetown, Massachusetts

Selected Group Exhibitions

2000 *Haulin' Ass,* Post Gallery, Los Angeles

Superduper New York, Pierogi 2000, Brooklyn

Brooklyn: New Work, Contemporary Art Center, Cincinnati

Re: Rauschenberg, Marcel Sitcoske Gallery, San Francisco

Valentine, Eyewash, New York

Rage for Art (Pierogi Reborn), Pierogi 2000, Brooklyn

1998 *Pop Surrealism,* Aldrich Museum of Contemporary Art, Ridgefield, Connecticut

Fashioned, White Box Gallery, New York

Flat Files (Organized by Pierogi 2000), Kunstlerhaus, Vienna; Rosenwald-Wolf Gallery, University of the Arts, Philadelphia; and Yerba Buena Center for the Arts, San Francisco

INKA ESSENHIGH

Born 1969, Belfonte, Pennsylvania

Lives and works in New York

Education

1991 B.F.A., Columbus College of Art and Design, Columbus, Ohio

1993 M.F.A., School of Visual Arts, New York

Selected Solo Exhibitions

2000 Victoria Miro Gallery, London

Mary Boone Gallery, New York

1999 *New Paintings,* Deitch Projects, New York

American Landscapes: Recent Paintings by Inka Essenhigh, New Room of Contemporary Art, Albright-Knox Art Gallery, Buffalo, New York

1998 *Recent Paintings,* Stefan Stux Gallery, New York

1997 *Wallpaper Paintings,* La Mama La Galleria, New York

Selected Group Exhibitions

2001 *Hybrids,* Tate Gallery, Liverpool

2000 *The Figure: Another Side of Modernism,* Newhouse Center for Contemporary Art, Staten Island, New York

Raw, Victoria Miro Gallery, London

Emotional Rescue: The Contemporary Art Project Collection, Center of Contemporary Art, Seattle

Deitch/Steinberg Editions: New Editions, Deitch Projects, New York

To Infinity and Beyond: Editions for the Year 2000, Brooke Alexander Gallery, New York

Greater New York, P.S. 1 Contemporary Art Center, Long Island City, New York

1999 *Pleasure Dome,* Jessica Fredericks Gallery, New York

The Armory Show 1999, with Stefan Stux Gallery, New York

A Room with a View, Sixth @ Prince Fine Art, New York

1998 *The New Surrealism,* Pamela Auchincloss Project Space, New York

Pop Surrealism, Aldrich Museum of Contemporary Art, Ridgefield, Connecticut

Celebrating Diversity: Contemporary Women Painters. Hillwood Art Museum, Long Island University, C. W. Post Campus, Brookville, New York

ANATOMY INTELLECT, Stefanelli Exhibition Space, New York

Wild, Exit Art/The First World, New York

Blade Runner, Caren Golden Fine Art, New York

1997 *Sex/Industry,* Stefan Stux Gallery, New York

Girls! Girls! Girls!, Tricia Collins Grand Salon, New York

1996 *Underexposed: Nine Young American Painters,* Andre Zarre Gallery, New York

Night of 1000 Drawings, Artists Space, New York

MIKA KATO

Born 1975, Mie Prefecture, Japan

Lives and works in Mie Prefecture, Japan

Education

1999 Aichi Prefectual University of Art

Selected Solo Exhibitions

2001 Contemporary Art Gallery, Art Tower Mito, Ibaragi

2000 Canaria, Tomio Koyama Gallery, Tokyo

MICHA KLEIN
Born 1964, Harderwijk, The Netherlands
Lives and works in Amsterdam

Education
B.F.A., Rietveld Academy, Amsterdam

Selected Solo Exhibitions

2000 *The Arrival of the Rainbow Children,* Mary Boone
 Gallery, New York

1999 Robert Sandelson Gallery, London

1998 Groninger Museum, Groningen, the Netherlands
 (catalog)

1992 *Survey 1985–1990,* Witzenhausen Meijerink Art
 Space, Amsterdam

Selected Group Exhibitions

2000 *SUPERMODEL: Identity and Transformation,*
 Lipanje Puntin Gallery, Trieste, Italy
 Bodies, Clothing, and Surfaces, Museum für
 Kunst und Gewerbe, Hamburg
 *Ghost in the Shell: Photography and the Human
 Soul,1850–2000,* Los Angeles County Museum
 of Art, Los Angeles

1999 *Spirituality of Beauty,* Marella Arte Contemporanea,
 Milan (catalog)
 *Visions of the Body: Fashion or Invisible
 Corset,* Museum of Contemporary Art, Tokyo

1991 *History of the Electronic Page,* Institute of
 Contemporary Art, Amsterdam

MILTOS MANETAS
Born 1964, Athens, Greece
Lives and works in Los Angeles and New York

Education
Visual Arts, Brera-Milan, Italy

Selected Solo Exhibitions

2000 *After Pokemon,* Galerie Analix, Geneva
 ?WORD: a new name for the Arts, Gagosian
 Gallery, New York

1999 *After Videogames,* Lux Gallery, London
 8 Perfect Paintings, Lawing Gallery, Houston
 *F O R – The Fabric of Reality after D.
 Deutsch,* Rebecca Camhi Gallery, Athens

1998 *MIRRORSITES 98,* Postmasters Gallery, New York

1997 *Playstation 64,* Galleria Il Capricorno, Venice
 PPP, and Rebecca Camhi Gallery, Athens

Selected Group Exhibitions

2000 *MURAKAMI—MANETAS (an HTML show),*
 Genova-Savona, curated by Francesca Pennone
 SINOPSIS, National Museum for Contemporary Art,
 Athens
 VERSION 2000, Centre pour L'Image
 Contemporaine, Geneva
 PICT, Center for Contemporary Art, Banff, Canada

1999 *Transmute,* Museum of Contemporary Art, Chicago

1998 *Usefool,* Postmasters Gallery, New York

1997 *Heaven-Private View,* P.S. 1 Contemporary Art
 Center, Long Island City, New York
 Technological Drift, Lawing Gallery, Houston
 Shopping, Deitch Projects, Guggenheim
 Museum, New York
 a/drift, Center for Curatorial Studies
 Museum, Bard College, Annandale-on-Hudson,
 New York

1995 *Country Code,* Bravin Post Lee Gallery, New York

PAUL McCARTHY
Born 1945, Salt Lake City, Utah
Lives and works in Los Angeles

Education

1969 B.F.A., San Francisco Art Institute, San Francisco

1973 M.F.A., University of Southern California,
 Los Angeles

Selected Solo Exhibitions

2001 *Paul McCarthy: Survey of Work,* New Museum,
 New York

1997 *Paul McCarthy,* MOCA at the Geffen ConTemporary,
 Los Angeles
 Heidi File, Patrick Painter, Inc., Santa Monica
 Paul McCarthy and Mike Kelley, The Power
 Plant, Toronto

1996 *Photographs – Performance Photographs and Video,
 1969–1983,* Luhring Augustine, New York; and
 Patrick Painter, Inc., Santa Monica

1995 *Painter,* Projects Room, Museum of Modern Art,
 New York

Selected Group Exhibitions

2000 *(In Between) The Hannover Expo,* Hannover,
 Germany

1998 *American Playhouse,* The Power Plant, Toronto,
 (catalog)
 Double Trouble, Museum of Contemporary Art,
 San Diego
 Pop Surrealism, Aldrich Museum of Contemporary
 Art, Ridgefield, Connecticut
 *Out of Actions: Between Performance and the
 Object, 1949–1979,* Museum of Contemporary
 Art, Los Angeles; travels to MAK, Vienna

1997 *Deep Storage;* travels to Haus der Kunst,
 Munich; Nationalgalerie, Berlin; Kunstmuseum,
 Düsseldorf; P.S. 1 Contemporary Art Center,
 Long Island City, New York; Henry Art Gallery,
 Seattle (catalog)
 Scene of the Crime, Armand Hammer
 Museum of Art and Cultural Center, Los Angeles
 (catalog)
 Sunshine & Noir, Louisiana Museum of Modern Art,
 Humleæk, Denmark; Kunstmuseum, Wolfsburg,
 Germany; Castello di Rivoli, Museo d'Arte
 Contemporanea, Rivoli, Italy; Armand Hammer
 Museum of Art and Cultural Center (catalog)
 Tableaux, Museum of Contemporary Art, Miami;
 travels to Contemporary Arts Museum, Houston
 (catalog)
 1997 Biennial Exhibition Portfolio, Whitney Museum
 of American Art Edition
 Performance Anxiety, Museum ofContemporary Art,
 Chicago; Museum of Contemporary Art, San
 Diego; and SITE Santa Fe, Santa Fe, New
 Mexico (catalog)

 1997 Biennial Exhibition, Whitney Museum of
 American Art, New York (catalog)
 Making it Real, Aldrich Museum of Contemporary
 Art, Ridgefield, Connecticut; travels to Reykjavik
 Municipal Art Museum, Reykjavik; Portland Art
 Museum, Portland, Oregon; Baylor Art Museum,
 University of Virginia, Charlottesville

1996 *a/drift,* Center for Curatorial Studies
 Museum, Bard College, Annandale-on-Hudson,
 New York

Everything that's interesting is new, Dakis Jannou
 Collection, Athens (catalog)
1995 *Familiar Places,* Institute of Contemporary Art,
 Boston

MARIKO MORI

Born 1967, Tokyo
Lives and works in New York and Tokyo

Education

Bunka Fashion College, Tokyo
1988–89 Byam Shaw School of Art, London
1989–92 Chelsea College of Art, London
1992–93 Whitney Museum of American Art, Independent
 Study Program, New York

Selected Solo Exhibitions

2000 *Mariko Mori,* Galerie Emmanuel Perrotin, Paris
 Link, Centre Georges Pompidou, Paris
1999 *Empty Dream,* Brooklyn Museum of Art, Brooklyn
1998 *Mariko Mori,* Museum of Contemporary Art,
 Chicago; Andy Warhol Museum, Pittsburgh;
 and Serpentine Gallery, London
1997 *Play With Me,* Dallas Museum of Art, Dallas
1996 *Made in Japan,* Deitch Projects, New York

Selected Group Exhibitions

2000 *Let's Entertain,* Walker Art Center, Minneapolis;
 travels to Portland Art Museum, Portland,
 Oregon; Centre Georges Pompidou, Paris;
 Museo Rufino Tamayo, Mexico City; St. Louis
 Art Museum, St. Louis; and Miami Art Museum,
 Miami
 Sons et lumières – L'Age du divertissement,
 Centre Georges Pompidou, Paris
 *Japanese Contemporary Art – Between Body and
 Space,* Center for Contemporary Art, Ujazdowski
 Castle, Warsaw
 *Apocalypse – Beauty and Horror in Contemporary
 Art,* Royal Academy of Arts, London
 Sydney Biennial
 *The Age of Influence: Reflections in the Mirror of
 American Culture,* Museum of Contemporary
 Art, Chicago
1999 *Regarding Beauty: A View of the Late Twentieth
 Century,* Hirshhorn Museum and Sculpture
 Garden, Washington, D.C.
 Seeing Time, San Francisco Museum of Modern
 Art, San Francisco
 Surrogate, Henry Art Gallery, University of
 Washington, Seattle
1997 International Istanbul Biennial
 Nordic Pavilion, Venice Biennale
 Past Present Future, Venice Biennale
 Johannesburg Bienniale

MR. (MASAKATU IWAMOTO)

Born 1969, Hyogo, Japan
Lives and works in Tokyo

Education

1996 Sokei Art School, Tokyo

Selected Solo Exhibitions

2000 *Venus #2,* Vedanta Gallery, Chicago
1998 Tomio Koyama Gallery, Tokyo Shop 33, Tokyo
1997 Aoi Gallery, Osaka
1996 Shop 33, Tokyo

Selected Group Exhibitions

2000 Art Forum Berlin (Vedanta Gallery), Berlin
 Art Chicago 2000 (Vedanta Gallery), Chicago
 Lovideo, Vedanta Gallery, Chicago
1999 *Attention Spam,* Shoshana Wayne Gallery,
 Santa Monica
 PO+KU Art Revolution, Hiropon Show, Logos Gallery,
 Tokyo
 Hiropon Show, Parco Gallery, Nagoya, Japan
1998 *Ero Pop Tokyo,* Hiropon Show, X-Large
 George Gallery, Los Angeles
 Ero Pop Christmas, Hiropon Show, Nadiff, Tokyo
1997 *Tokyo Sex,* NAS, Tokyo
 Hiropon Show, Shop 33, Tokyo
1996 *Pico Pico Show,* Tomio Koyama Gallery, Tokyo

TAKASHI MURAKAMI

Born 1962, Tokyo
Lives and works in Tokyo and New York

Education

B.F.A., Tokyo National University of Fine Arts
 and Music, Department of Traditional Japanese
 Painting (Nihon-ga), Tokyo
1988 M.F.A., Tokyo National University of Fine Arts
 and Music
1993 Ph.D., Tokyo National University of Fine Arts and Music

Selected Solo Exhibitions

2001 Blum & Poe, Santa Monica
 Takashi Murakami, Museum of Fine Arts, Boston
 Marianne Boesky Gallery, New York
2000 *Takashi Murakami: S.M.P.K.02,* P.S. 1
 Contemporary Art Center, Long Island City, New York
1999 *Takashi Murakami,* Center for Curatorial Studies
 Museum, Bard College, Annandale-on-Hudson,
 New York (catalog)
 Super Flat, Marianne Boesky Gallery, New York
1998 *Back Beat,* Blum & Poe, Santa Monica Feature, Inc.,
 New York

Selected Group Exhibitions

2001 *Beau Monde: Toward a Redeemed Cosmopolitanism,*
 Fourth International Biennial, SITE Santa Fe,
 Santa Fe, New Mexico
 Public Offerings, Museum of Contemporary Art,
 Los Angeles
 Painting at the Edge of the World, Walker
 Art Center, Minneapolis, travels (catalog)
 Super Flat, Museum of Contemporary Art, Los
 Angeles, travels (catalog)
2000 *The Darker Side of Playland: Childhood Imagery
 from the Logan Collection,* San Francisco
 Museum of Modern Art, San Francisco
 Let's Entertain, Walker Art Center, Minneapolis;
 travels to Portland Art Museum, Portland,
 Oregon; Centre Georges Pompidou, Paris;
 Museo Rufino Tamayo, Mexico City; St. Louis
 Art Museum, St. Louis
1999 *The Carnegie International,* Carnegie Museum of
 Art, Pittsburgh
 *Almost Warm & Fuzzy: Childhood and
 Contemporary Art,* Des Moines Art Center,
 Des Moines; travels to Tacoma Art Museum,
 Tacoma, Washinton; Scottsdale Museum of
 Contemporary Art, Scottsdale, Arizona; P.S. 1
 Center for Contemporary Art, Long Island City,
 New York; Fundacio La Caixa, Barcelona;

Crocker Art Museum, Sacramento, Art Gallery
of Hamilton, Ontario; and Cleveland Center for
Contemporary Art, Cleveland

1998 *Abstract Painting, Once Removed,* Contemporary
Arts Museum, Houston; travels to Kemper
Museum of Contemporary Art, Kansas City,
Missouri (catalog)
Asia-Pacific Triennial 1996, Queensland Art Gallery,
Brisbane

1995 *Transculture,* Venice Biennale

YOSHITOMO NARA

Born 1959, Aomori Prefecture, Japan
Lives and works in Cologne, Germany, and Nagoya, Japan

Education

B.F.A. Aichi Prefectural University of Fine Arts and
Music, Aichi, Japan

1987 M.F.A. Aichi Prefectural University of Fine Arts and
Music, Aichi, Japan
Kunstakademie Düsseldorf, Germany

Selected Solo Exhibitions

2001 Yokohama Museum of Art, Yokohama, Japan;
travels to Hiroshima Museum of Contemporary
Art; Ashiya City Museum of Art; Asahikawa
Prefectural Museum of Art; and Aomori Museum
of Art (catalog)
Blum & Poe, Santa Monica

2000 *Lullaby Supermarket,* Santa Monica Museum of Art,
Santa Monica
Walk On, Museum of Contemporary Art, Chicago

1999 Marianne Boesky Gallery, New York

Selected Group Exhibitions

2001 *Super Flat,* Museum of Contemporary Art,
Los Angeles, travels (catalog)

2000 *The Darker Side of Playland: Childhood Imagery
from the Logan Collection,* San Francisco
Museum of Modern Art, San Francisco

1999 *Almost Warm & Fuzzy: Childhood and
Contemporary Art,* Des Moines Art Center,
Des Moines; travels to Tacoma Art Museum,
Tacoma, Washinton; Scottsdale Museum of
Contemporary Art, Scottsdale, Arizona; P.S. 1
Center for Contemporary Art, Long Island City,
New York; Fundacio La Caixa, Barcelona; Crocker
Art Museum, Sacramento, Art Gallery of
Hamilton, Ontario; and Cleveland Center for
Contemporary Art, Cleveland
New Modernism for a New Millennium,
San Francisco Museum of Modern Art,
San Francisco

1998 *The Manga Age,* Museum of Contemporary Art,
Tokyo (catalog)

RICHARD PATTERSON

Born 1963, Leatherhead, Surrey, England
Lives and works in London

Education

Watford College of Art and Design Foundation Course,
Watford, Hertfordshire
B.F.A. Hons., Goldsmiths College, London

Selected Solo Exhibitions

2000 *Concentration 35: Richard Patterson,* Dallas
Museum of Art, Dallas

1999 James Cohan Gallery, New York (catalog)
Anthony d'Offay Gallery, London (catalog)

1995 Project Space, Anthony d'Offay Gallery, London

Selected Group Exhibitions

1999 *Mode of Art,* Kunstverein for die Rheinlande
und Westfalen, Düsseldorf, July 24–October 10,
1999 (catalog)
Negotiating Small Truths, Jack S. Blanton
Museum of Art, Austin, Texas
*Sensation: Young British Artists from the
Saatchi Collection,* Royal Academy of Arts, London;
Hamburger Bahnhof-Museum für Berlin; and
Brooklyn Museum of Art, Brooklyn (catalog)

1998 *Abstract Painting, Once Removed,* Contemporary Arts
Gallery, Houston (catalog)

1997–98 *Pictura Britannica: Art from Britain,* Museum of
Contemporary Art, Sydney Art Gallery of South
Australia, Sydney, and City Gallery of Wellington,
New Zealand (catalog)
False Impressions, British School at Rome,
Italy (catalog)

1996–97 *About Vision: New British Paintings in the 1990s,*
Museum of Modern Art, Oxford; Fruitmarket
Gallery, Edinburg; Laing Art Gallery, Newcastle
(catalog)

1996 *Portrait of the Artist,* Anthony d'Offay Gallery, London
Answered Prayers, Contemporary Fine Arts, Berlin
ACE!: Arts Council Collection of New Purchases,
Hatton Gallery, Newcastle; Harris Museum and Art
Gallery, Preston; Oldham Art Gallery, Oldham;
Hayward Gallery, London; Museum and Art Gallery,
Walsall; Mappin Art Gallery, Sheffield; Angel Row
Gallery, Nottingham; Arnolfini, Bristol; Royal
Museum, Canterbury

TOM SACHS

Born 1966, New York
Lives and works in New York

Education

1987 Architectural Association, London
B.A., Bennington College, Bennington, Vermont

Selected Solo Exhibitions

2000 *Test Module Five (Urinal),* Tomiyo Koyama
Gallery, Tokyo

1999 *Haute Bricolage,* Mary Boone Gallery, New York
SONY Outsider, SITE Santa Fe, Santa Fe,
New Mexico
Tom Sachs, Mario Diacono Gallery, Boston

1998 *Creativity is the Enemy,* Thomas Healy
Gallery, New York

1997 *Cultural Prosthetics,* John Berggruen Gallery,
San Francisco
Tom Sachs, Galeria Gian Enzo Sperone, Rome

Selected Group Exhibitions

2000 *American Bricolage,* Sperone Westwater, New York

1999 *Readymade Project,* Wunderkammer, London
Exposing Meaning in Fashion Through Presentation,
Brooklyn Bridge Anchorage, Brooklyn
Thinking Aloud, Kettle's Yard, Cambridge;
Cornerhouse, Manchester; and Camden Arts
Centre, London (catalog)

1998 *Ensemble Moderne: The Still Life in Contemporary
Painting and Sculpture,* Galerie Thaddeus
Ropac, Salzburg and Paris (catalog)

1997 *Icons: Modern Design and the Haunting Quality of Everyday Objects,* San Francisco Museum of Modern Art, San Francisco

1996 *Shred Sled Symposium,* Thread Waxing Space, New York

MOMOYO TORIMITSU
Born 1967, Tokyo
Lives and works in New York

Education
B.F.A., Tama Art University, Tokyo
P.S. 1 Studio Program, Long Island City, New York

Selected Solo Exhibitions
2000 *Green,* Deitch Projects, New York
 Momenta Art, New York
1996 Gallery MYU, Tokyo
1995 Gallery MYU, Tokyo
1994 Gallery MYU, Tokyo

Selected Group Exhibitions
2000 *Dark Mirrors of Japan,* De Appel, Amsterdam
1999 *Videodrome,* New Museum of Contemporary Art, New York
 Best of Season, Aldrich Museum of Contemporary Art, Ridgefield, Connecticut
 Abracadabra, Tate Gallery, London
 Contact, Jack Tilton Gallery, New York
 Spiral TV, Spiral Gallery, Tokyo
1998 *Where I am,* Galeria da Mitra, Lisbon
 Attack/Damage, Itabashi Art Museum, Tokyo
1997 *Expansion Arts,* Alternative Museum, New York
 Documents and Art, Museum Ginza, Tokyo
 Zones and Disturbances, Steirischer Herbst, Graz, Austria
 P.S. 1 National and International Studio Artists, Clocktower Gallery, New York
1996 *Art X=,* Sam Museum, Osaka
 Human Figure, O Art Museum, Tokyo
1995 *Morphe '95, City Crack,* Mizuma Art Gallery, Tokyo
 Art Artist Audition '94, La Foret Harajuku, Tokyo

CHARLIE WHITE
Born 1972, Philadelphia
Lives and works in Los Angeles

Education
1994 Yale Summer Program, Norfolk, England
1995 B.F.A., School of Visual Arts, New York
 M.F.A., Art Center College of Design, Pasadena

Selected Solo Exhibitions
2001 Andrea Rosen Gallery, New York
1999 *In a Matter of Days,* Andrea Rosen Gallery, New York
 Santa Barbara Contemporary Arts Forum, Santa Barbara

Selected Group Exhibitions
2000 *Above Human,* Yerba Buena Center for the Arts, San Francisco
1999 *Almost Warm & Fuzzy: Childhood and Contemporary Art,* Des Moines Art Center, Des Moines; travels to Tacoma Art Museum, Tacoma, Washinton; Scottsdale Museum of Contemporary Art, Scottsdale, Arizona;

 P.S. 1 Center for Contemporary Art, Long Island City, New York; Fundacio La Caixa, Barcelona; Crocker Art Museum, Sacramento, Art Gallery of Hamilton, Ontario; and Cleveland Center for Contemporary Art, Cleveland
1996 *The Name of the Place,* Casey Kaplan Gallery, New York
1995 *Somatogenics,* Artists Space, New York

KENJI YANOBE
Born 1965, Osaka, Japan
Lives and works in Osaka

Education
Graduated Kyoto City University of Arts, Kyoto
M.A., Kyoto City University of Arts, Kyoto

Selected Solo Exhibitions
2000 University Art Museum, Santa Barbara
 Babilonia 1808, Berkeley
1997 Yerba Buena Center for the Arts, San Francisco

Selected Group Exhibitions
2000 *Trading Views,* Stadt Galerie Saarbrüken, Germany; Stadtische Galerie Erlangen, Germany; and Stedelijk Museum De Lakenhal, Leiden, the Netherlands *GENDAI: Japanese Contemporary Art – Between the Body and Space,* Centrum Sztuki Wspolczesnej, Poland
 Gift, Museum of Contemporary Art, Tokyo
 Melbourne International Biennial
1998 *Et maintenant!,* Ecole Nationale Supérieure des Beaux-Arts, Paris
1997 *Transit–60 Artists Born after the 60s,* Collection of Fonds National d'Art Contemporain, Ecole Nationale Supérieure des Beaux-Arts, Paris
1996 *Discord, Sabotage of Realities,* Kunstverein and Kunsthaus Hamburg, Hamburg
 Moving Art in the 20th Century, Museum of Modern Art, Wayama, Japan

Des moines art center

Founded in 1948 to engage people with the art of our times, the Des Moines Art Center has become a world-class museum in the heart of the Midwest. In landmark buildings by Eliel Saarinen, I. M. Pei, and Richard Meier, the Art Center presents an important collection of nineteenth-, twentieth-, and twenty-first-century art and conducts educational programs to foster life-long learning in the arts. Special exhibitions are organized to focus on eminent artists and intriguing issues. Many of the Art Center's original exhibitions travel nationally and abroad, expanding its influence beyond regional borders.

Independent Curators International

Independent Curators International (ICI), New York, is a nonprofit organization dedicated to enhancing the understanding and appreciation of contemporary art, and to making new art accessible to the broadest possible audience. Founded in 1975, ICI collaborates with eminent curators from throughout the world to organize innovative and challenging exhibitions that travel both nationally and internationally. The exhibitions that ICI develops, organizes and circulates, along with the catalogs it publishes to accompany its exhibitions, feature a thought-provoking mix of subjects and artists and present a variety of recent trends and aesthetic concerns. ICI has, to date, created almost 100 exhibitions, which have included the works of more than 2000 artists and been presented by over 400 arts institutions across the U.S. and in eighteen other countries.

Alexander and Bonin, New York
Matthew Benedict
Paul and Estelle Berg
John Berggruen Gallery, San Francisco
Blum & Poe, Santa Monica
Marianne Boesky Gallery, New York
Mary Boone Gallery, New York
Lee Bul
Taro Chiezo
James Cohan Gallery, New York
Deitch Projects, New York
The Dikeou Collection, Denver
James Esber
Inka Essenhigh
Josef W. Froehlich
Sandra Gering Gallery, New York
Sue Hancock
Marc Jancou Fine Art, New York
Saito Kazunori
Lisa Kenney
Micha Klein
Tomio Koyama Gallery, Tokyo
Gallery Koyanagi, Tokyo
Miltos Manetas
Victoria Miro Gallery, London
Mariko Mori
Mr. (Masakatu Iwamoto)
Yoshitomo Nara
Neuberger Berman, New York
Eileen and Peter Norton
PKM Gallery, Seoul, South Korea
P.P.O.W., New York
Rontgen Kunstraum, Tokyo
Andrea Rosen Gallery, New York
Robert Sandelson, London
Barbara Schwartz
Gian Enzo Sperone
Sperone Westwater, New York
Speyer Family Collection
Momoyo Torimitsu
Vedanta Gallery, Chicago
Charlie White
Babilonia Wilner Collection, Berkeley
Glenn Scott Wright
Galerie Xippas, Paris
Kenji Yanobe

photography credits